SHE
LOOKS
FINE

Love,
Paige

With
gratitude,
Roberta

A Mother and Daughter's Journey Through a TBI

Roberta Campbell Knechtly & Paige Knechtly

O'LEARY
PUBLISHING
The Influencer's Press

NAPLES, FL

ISBN: 978-1-952491-40-5 (paperback)

ISBN: 978-1-952491-41-2 (ebook)

Library of Congress Control Number: 2021924416

Printed in the United States of America

Book Design by Jessica Angerstein

To anyone who has experienced an invisible injury
or lived through a major traumatic experience –
may you find the support and answers
you need to live a peaceful life.

CONTENTS

Traumatic brain injury (TBI) is a leading cause
of death and disability among children and
young adults in the United States.
Each year, an estimated 1.5 million
Americans sustain a TBI.

– CENTERS FOR DISEASE CONTROL AND PREVENTION

PREFACE

LIVES FOREVER CHANGED

I was living my best life as an empty nester while traveling to California to further my career when I received a call that would change my life forever – my daughter Paige had been in an accident. We never dreamed this would happen – and in the years following, both of our lives changed in ways we could never have imagined.

We were in the dark so much of the time about what was happening; and so we are telling our story to provide encouragement and tools to those navigating the same road we have walked. This is a book filled with the lessons we have learned along the way, and we hope it will help you on your journey. At the end of each chapter, we

will share the lessons that we learned during each part of the process.

If you have experienced a traumatic situation, we want you to know you are not alone. *She Looks Fine* is our story of making the best out of an unfortunate situation and our way of helping you find possible treatments and solutions. This is also the story of how a mother and a daughter found each other anew in an impossible situation and forged an incredible bond as a team united in the goal of healing.

There are hundreds of thousands of undiagnosed brain injuries, as well as unexplained disorders, that need to be addressed. We hope to present you with a better understanding of the invisible injury – a traumatic brain injury (TBI). We would like to raise awareness of the severity of the condition and educate others about ways to continue healing from this life-altering injury.

USING THIS BOOK

In *She Looks Fine*, we share the perspective of both the patient and the caregiver. You may want to read through the whole book, or you may choose to read just the parts that help you in your situation.

IT'S PROLLY GONNA BE
HARD TO HEAR THIS

ALL MY PAIN
YOU GONNA REALLY
FEEL IT

I HATE TO GET
SO SERIOUS

I ALMOST DIED AND
IT TURNED ME
FEARLESS

— FEARLESS BY PAIGE

ROBERTA

CHAPTER 1

THE CALL

After working behind the chair for many years, it was time to expand my career as a hairstylist. I had been in a salon for over 30 years and had a passion for making clients look and feel beautiful, while also listening to their problems and encouraging them.

After some time, it became physically demanding and I knew I would not be able to continue that particular job forever. I have always had the desire for more. Before having children, I was an educator at a salon and loved traveling and teaching new hair techniques to my colleagues. Over the years, I had also tried network marketing – without much success – but my passion always led me back to helping others. I began searching for an opportunity to teach again – and the next thing I knew, it happened!

Opportunity does not just come knocking on your door – you have to ask for it and look for signs leading you in the right direction. One day, while picking up supplies for the salon, I noticed a sign advertising a position as an educator for a hair extension company. I had extensions myself in the past; I knew the benefits. I was excited to learn this technique and instantly expressed my desire to schedule an interview.

If you want to make changes, it is imperative to move out of your comfort zone. Although it would be a challenge for me, I knew that in order to move forward in my career, I had to do what was necessary. I was interviewed and hired!

I traveled to many cities, including Sacramento, California, to teach classes, after which I extended my trip around California and drove to Lake Tahoe and the Napa Valley. I spent the time relaxing and reflecting on my life.

Lake Tahoe was one of the most picturesque places I have ever been, and filled with rich history. I was in heaven. Next, I enjoyed a few days sipping wine while enjoying the beautiful scenery in the wine country of California, and relaxing poolside. I had chosen a few vineyards to explore and sampled a variety of delicious wines. I was living my dream life!

I was having a great time, but I missed my children terribly. This was one of the first trips I had taken by myself – and even though my kids were not there, I remained in close contact with them. Our relationships grew stronger as time went on.

My children were in college and I was an empty nester. There is a feeling of relief and excitement when your children move out on their own. Paige was in her fifth year of college, working part time, and getting ready to begin her life as an adult. My son Jake was in his second year of college and moving forward in his life.

I had been living beyond my means, trying to give my children the same lifestyle they had been accustomed to prior to my divorce. Once I decided to sell my home, everything happened fast. I had no idea where I was moving; but I knew I was ready for a change.

I found an apartment in a cute little town overlooking a river. The bonus was that I was within walking distance to restaurants, boutiques and a brewery. I felt so blessed! I could not believe how fortunate I was to have found this spot. Finally, everything was falling into place.

As much as I enjoyed all of the traveling, it was time for me to branch out and start teaching my own classes with a different company. Another hair-extension company

approached me to join their team, and after much debate, I decided to go for it!

Change is always scary at first; but I knew if I did not jump on the opportunity, I would never become successful or make more money. I loved my career, but I was becoming burned out – not to mention that I needed to increase my income. I loved teaching hair extension classes, so this new company seemed like the perfect opportunity for the next chapter in my life.

The training required me to take another trip to California – this time to Orange County. I was thrilled when a friend was able to travel with me, and we had a wonderful time taking in the sights from Los Angeles to Malibu, and down Highway 1 to Orange County. The beauty of the coastline was breathtaking, but I missed my children and wished they were with me.

I could not believe all of these opportunities to travel! I was having the time of my life! I have been fortunate to have visited a lot of places, but there were so many places I still wanted to see.

Early on a Monday morning, I was awakened by a call from my daughter Paige, telling me she had been in an accident and was in the emergency room. I was groggy because of the three-hour time difference, and I could not understand Paige or the situation at hand. She sounded

fine – and she was with a college friend. I had so many questions, but I was still very foggy from sleep.

My girl was in crisis and I was 3,000 miles away. Her whole life flashed before my eyes. I thought back to that special day in July, 1996, when she came into this world. It was one of the happiest days of my life. She was a gift from God. What had happened to her? Was Paige going to be OK?

LESSONS LEARNED

- Continue to learn and grow – not only in your career, but also in life.

- Listen to your intuition and let it guide you, since it is God's way of speaking to you.

- Decide what you love to do, and make it happen!

CHAPTER 2

A STAR IS BORN

Paige and I had grown close in the past few years since the divorce, and I could not wait to arrive back home and see her. As I flew across the country toward my girl, I thought back to her beginnings. I had plenty of time on the flight to think about her childhood.

My pregnancy with Paige was fairly easy, except for swollen feet and a little heartburn. One of my friends jokingly said that I was meant to have children! I was excited and nervous and could not wait to hold my baby; and on July 20, 1996, I gave birth to a beautiful baby girl. Paige was perfect in my eyes and by her Apgar score of 9.9, she was as healthy as a baby could be.

The first night in the hospital, I walked to the nursery to check on my new baby. I thought it was unusual that they had not brought her in to nurse. She was sleeping, so they told me to rest while I had the opportunity. A little reluctant at first, I walked back to my room and went back to sleep. I had heard horror stories of new parents being sleep-deprived, so I was aware of the importance of resting as much as possible.

After arriving home from the hospital, Paige woke up during the first night. But then she began sleeping through the night. I had no idea how fortunate I was. This lasted for about 10 months, and then she began waking up in the middle of the night. My luck had not lasted forever! I was still grateful for the peaceful nights prior – and I would eventually understand how it would feel to be sleep-deprived.

I read all the latest parenting books in hopes of becoming the best mom I could be. Maybe I became a little obsessed, or maybe I was afraid I was not doing the mom thing right – I was probably more on the obsessed side! I wanted the best for Paige, and I wanted the knowledge to be able to challenge her to be the best she could be.

I know now that there is no official guide to becoming a parent. I was so focused on trying to do what I thought was best that I missed many fun moments. As parents,

my ex-husband and I must have done something right because I constantly heard how well-behaved and considerate my children were – and still are to this day.

MUSIC

From the day they were born, I knew the importance of introducing my children to a wide range of music genres. To begin with, I enrolled Paige into a Kindermusik program, an interactive children's musical program. I read how beneficial music could be for helping children develop math and other skills at a young age, so I began researching activities to support that growth.

As a bedtime ritual, I would sing a lullaby that I had written, with the intention of creating a soothing nightly routine. I have always had a passion for music. As a child, I remember holding an imaginary microphone in my hand while performing for my grandparents. They were the best audience because they loved everything I sang!

As time went on, in addition to reading bedtime stories, we would listen and dance to music throughout the day. As soon as she could speak, Paige began singing. She has a beautiful voice and we really enjoyed singing the gospel hymns that I learned to sing from my mom. We also sang together at church – like I did with my two older sisters when I was younger.

Since Paige was our first child, and we had no other children the same age in our extended family, I found a playgroup for her to develop her socialization skills. All of the moms were either stay-at-home moms or they only worked part-time, and the children were not enrolled in a child-care facility. The benefits of gathering together regularly were great for all of us. Paige learned to interact with other children really well before attending preschool.

Paige thoroughly enjoyed spending time with her new friends and was very good at learning to share her toys. We would meet weekly to bring the kids together while planning activities we thought they would enjoy. Of course, we loved socializing with each other too, so it was a perfect situation.

SINGING

One year for Christmas, Paige received a karaoke machine, which she used to sing along with her friends – or by herself – almost every day. They would sing along to the latest songs on the radio, memorizing every word, while dancing to the beat and pretending they were on stage performing for a crowd. Growing up, Paige listened to all genres of music; but as she grew older, she developed a love for the songs on the *Billboard* magazine Hot 100 chart.

Paige always had a big imagination. While having friends over to visit, they would make up plays or dance routines and ask the parents to come watch them perform. When she was a toddler, Paige was easygoing, so I thought she might be more of a follower; but as she grew older, she began to show her propensity to take charge.

On the last day of preschool, all of the students received an award based on their progress or best traits chosen by the teacher. As they proceeded to call out the kids' names, I anxiously waited to hear what award Paige would be receiving. While many of the students' awards were scholastic, my daughter received the award for **A Good Friend.** At first, I was surprised; but the more I thought about it, I realized being a good friend was one of Paige's greatest assets. Still today, she would do anything for a friend. She has a big heart and would step up to help anyone in need.

When she was around the age of 6, I enrolled Paige in ballet, tumbling, and tap dance classes, which she thoroughly enjoyed – especially performing on stage for the recital. Surprisingly, Paige was not nervous at all! She had so much confidence on stage that the other girls looked to her to make sure they were doing the correct steps.

When Paige was about 7, my friend and I took our daughters to see Britney Spears in concert – landing seats in row 7! Britney was phenomenal on stage, and

like most of the other girls in the audience, Paige could not stop talking about seeing herself being able to perform on stage.

Maybe that was the moment she decided she wanted to become a singer – or maybe she always had that dream – but as her mom, I could begin to see a passion growing within her. By the time she was 10, Paige and a friend performed the song "You're The One That I Want" by Olivia Newton John and John Travolta in a school talent show. They were so confident and enjoyed every minute.

I was proud of Paige and of the beautiful girl she was becoming. I had participated in plays myself, so attending these events were a treat for me. It is interesting to watch our children participate in the same activities that we did as a child. Our genes really are passed on to our children – even personality traits. While growing up, I suffered from insecurities, and I knew the importance of teaching my kids how to develop self-confidence.

A few years later, during another school talent show, Paige and a friend performed a dance routine to the song "Car Wash" by Rose Royce. Paige went on to join the middle school choir, to which she showed great dedication, as they had class every day before school.

She was then given the opportunity to participate in the high school musical, *Seussical The Musical,* in which

she played the lion. Performing in the musical took Paige and her friends out of their comfort zone and strengthened their self-confidence even more. That experience played a profound role in Paige's childhood.

Paige was friendly, outgoing and a good student throughout her school years. She rarely missed a day of school because she enjoyed being around her friends and did not like missing out on any events.

Being very athletic, my kids began playing organized basketball and soccer, as well as other sports. Their father was involved in their sports activities; many times, he would coach. Paige also loved the water and was involved in swimming lessons. I had never been a good swimmer, so it was important for my children to learn at a young age.

Athletics have always been a part of my children's lives; but music would have the biggest influence on Paige. Since a neighbor – one of her best friends – was taking piano lessons, Paige began taking lessons as well. In middle school, Paige joined the band and played the flute, using the same flute I played growing up. Even though she did not continue lessons on any of those instruments, the experience was worth it.

When my children were young, I enjoyed taking them to festivals so they could ride rides and play games. I

recall one game involving spinning a wheel – and when the wheel landed on a particular spot, you would have the opportunity to choose the prize that was designated on that spot. While many kids played the game and ended up with a small prize, Paige won the grand prize! Things like that seemed to happen for her all of the time. Was it luck, or did she have such a positive attitude that she attracted good things?

Because of her love for music, Paige joined the school choir, where she remained a member for all of her school years. This led to an opportunity to spend a weekend at a local college with a select group of students for Honor Choir. The students were challenged to perform songs in foreign languages while learning to adapt to unfamiliar surroundings. This experience was life-changing, because it gave students a glimpse of possible future opportunities in the music industry.

Later, a client of mine had a connection with a school of performing arts and offered to write a referral letter when we were ready to apply; but, it did not work out due to parental differences. It was around that time that my husband and I divorced – Paige was 13 and Jake was 11.

STRUGGLES

My children were raised in a stable household and loved dearly. We always generously provided for them and they were given many opportunities to thrive. We took them on vacations to a variety of places, including Disney World and the Bahamas. Paige and Jake are well-rounded and know to treat others with respect. Of course, I feel like I could have done many things better – but then, most of us feel that way.

I never asked my children **if** they were going to college – I asked **where.** Paige was ecstatic when she was accepted to the University of Cincinnati. Paige changed her major several times and eventually declared a health education major. Eventually, it was obvious that she was not happy with her choice. While she would have been good at helping people learn about positive health choices; the only time she really came alive was when she was singing.

I could not help but think she was missing out on finding her true purpose in life. I believe we are born with certain gifts, and Paige was born to be a singer and entertainer – but was it too late?

LESSONS LEARNED

- Give your children some time and space to decide what excites and motivates them.

- Encourage them to follow their true passion and allow them to make decisions.

- Accept that growth happens through making mistakes and subsequent reflection.

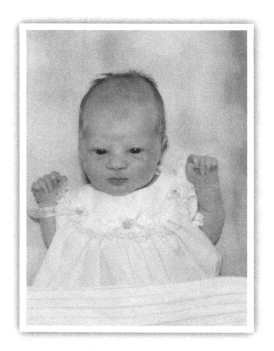

Paige as a 7-pound, 4-ounce newborn, July 20, 1996.

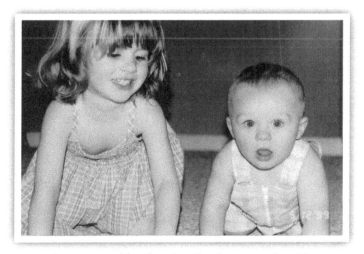

Paige, 2, and her brother Jacob, 9 months old,
in their childhood home.

A future star!

All ready for a dance recital!

CHAPTER 3

NOT MY DAUGHTER

DAY ONE

I cannot tell you how many times I have relived the moment when I was at training in California and received the call from Paige. She sounded **fine**; but I would find out later that she was not. During the few hours we were in class, Paige had called me several times; but I still did not understand the severity of the accident. I would learn later that Paige did not remember the accident; and so the whole situation was confusing to her.

After class, it took several phone calls to even understand her correctly. At first I thought she said that she was in a car accident; but then she was telling me that she was

hit by a car. I was in shock. I needed to be with Paige – but I was so far away, and had no idea when I would be able to make it to the hospital.

I reached out to a family member, and they were able to spread the word. A little while later, I was able to speak to her neurosurgeon who said that Paige had suffered a skull fracture, TBI, and other injuries. Luckily, my friend who was with me was a nurse, so she was able to translate what the neurosurgeon was saying. I knew I needed to travel home immediately, but it was too late to book a flight for that evening. I wondered how I was going to make it through that night. My son and my ex-husband were able to visit Paige and they assured me she was doing **fine** – but also mentioned she was not acting like herself.

The next day, on the drive to the airport, I was a complete mess. My parents had come to the hospital to visit Paige, and reassured me that she was doing **fine** at the moment. I felt better knowing they were with her.

My anxiety was out of control. I decided to redirect my focus instead of just sitting and waiting for the next flight. In between connecting flights, I frantically ran around the airport searching for something to take to Paige that would cheer her up or help with the pain. She had been complaining about having a horrible headache – so I

found a kiosk with aromatherapy items in hopes of giving her something that would bring her some relief.

It was the longest day of my life. Being that far away was killing me. I am a very emotional person and I could not stop crying. Everyone kept asking me if I was OK, so my friend had to explain my situation.

When I finally arrived at the hospital, I had no idea what to expect. I had spoken to Paige on the way to the hospital and she was able to communicate with me. I could not get to her room quickly enough; all I wanted was to see my girl, although I was afraid of what I might see when I got to her room. I passed visitors in the waiting room crying and holding each other, and my anxiety started to get the best of me.

A couple of Paige's childhood friends were visiting when I arrived. She had some scrapes and bruises; her left foot seemed to have suffered the most damage. Apparently, most of her injuries were invisible. She seemed **fine** due to all of the pain medication – and because of the love and support she was receiving. On the other hand, her cognitive abilities seemed childlike. She was acting sweet and sort of adolescent.

When Paige saw me, she immediately asked for the teddy bear I had bought her. Ironically, I had looked for a teddy bear at the airport but could not find one I liked

– but I did bring the aromatherapy oils. She kept saying, "Mommy, Mommy, Mommy," begging for my attention every chance she could get. It was so out of character for her, since she was a 22-year-old college student and had been living on her own for a few years. I was relieved that she was **fine**, but I was also confused.

DAY TWO

The next morning, I found the perfect teddy bear in the hospital gift shop, which made Paige happy; but I had missed the doctors making their rounds. I learned very quickly not to leave the room until I received an update from the medical staff.

Paige had fully reverted back to her old, childhood self. It seemed odd at first, and I wondered how long it would last. Paige proceeded to show me all of her injuries – and I was in shock. I started to gather more information, reviewing the accident report and discussing all of Paige's injuries with her nurses and doctors.

I learned that when the vehicle struck her, she hit the front of her skull on the windshield; and when she fell off the vehicle, she cracked the back of her skull on the concrete. This led to a skull fracture, bruising, swelling, and bleeding on her brain – not to mention other invisi-

ble injuries. Weeks later, I would find out that Paige had also been unconscious for almost 30 minutes.

When a person hits their skull, or suffers a jolt to the head, the internal injuries can be worse than any outside scrapes or bruises one might see with the naked eye. The name for this brain injury is a traumatic brain injury (TBI). It is why someone with a TBI often **looks fine** on the outside, but exhibits strange and confusing behaviors after the incident, which may persist for a long time to come. We did not completely understand the extent of her injuries.

Paige also suffered chronic neck and back pain, disk protrusions and other issues down her spine, nerve damage down her left leg and into her left foot, bone bruising on the same foot, chronic full-body pain, fatigue, and more. I could not believe how strong Paige was, considering the severity of the accident. Thankfully, she had not had any seizures or strokes, but we could not rule out the possibility of those occurrences in the future.

I will never be able to completely explain the emotions we experienced. I felt alone and scared and filled with anxiety – but unbelievably grateful that my daughter was alive. That was the moment I learned to lean on God for help. I knew there was some reason Paige was still here.

To my surprise, the injuries Paige sustained continued to get worse, and the migraines were almost unbearable. The pain medication only helped her for a few hours at a time. I had never witnessed anything like that before.

Paige could only walk with the use of a walker and needed assistance to use the bathroom. She wore an eye mask 24 hours a day, because the light caused excruciating pain to her head. She had no appetite, and any noise was almost unbearable. It was so difficult to see her like that.

I slept on the couch in her room and vowed not to leave her side. It was uncomfortable – and combined with all of the noise in the hospital, it was almost impossible to get any rest. I woke up in the middle of the night whenever Paige needed to go to the bathroom, and had to call for a nurse's assistance, since it took two of us to help Paige out of bed. Paige was in great pain, and even getting up to go to the bathroom took all of her effort.

DAY THREE

I still had no idea how long Paige would be in the hospital. Luckily, I had a suitcase full of clothes and essentials with me. A couple of my friends stopped by to drop off food, emotional support, and a Bible. My friends wanted to help, and insisted on coming to the hospital, even though

I said we did not need anything. I am forever grateful for each one of them.

Paige had no appetite for the first few days, due to her excruciating headache. Since I had missed speaking to the doctor that first morning, I made sure I stayed in the room to see him the following morning. I was such a mess – I did not understand what he was saying, and had no idea what questions to ask. Anxiety was getting the best of me, and I was embarrassed to speak up or ask about anything.

I began meditating in the hospital to help calm my mind. Meditation was difficult at first, so I experimented with many different techniques until I found one that worked for me. I have suffered from anxiety most of my life and had only tried meditating a few times in the past. Often, dark times can bring you closer to God, so I was trying to make the most of this time by staying connected.

I had been coasting through life and had never been through this type of trauma before. In the past, I avoided difficult situations and suppressed my emotions. But this time was different. I felt numb but I wanted to scream at the top of my lungs. I wanted to run away. And if it were not for being a mom and having the responsibility for my daughter, maybe I would have run away. Instead, I just sat there, not knowing what to do or say. When all of a sudden my world completely stopped, I turned to God.

Jeremiah 29:11 has always been my favorite Bible verse, and it kept repeating in my head: *For I know the plans I have for you, plans to prosper you and not to harm you, plans to give you hope and a future.*

I will never forget the moment when the pain was so excruciating for Paige that she put my hand on her skull and begged me to massage the pain away. I was afraid I might hurt her if I pushed too hard on her fractured skull or injured brain. It was difficult to see her in that much pain, knowing there was nothing I could do. I felt totally helpless.

Since I had never heard of a TBI, I had no way of knowing all that it entailed. I could imagine the injury from a broad point of view; but I did not understand the complications that came with it, or the many side effects that can last for a lifetime. I had no idea what to expect; but luckily while we were in the hospital, a friend gave me an article with some information explaining a TBI. The list of side effects include:

- Dizziness

- Nausea

- Confusion

- Migraines

- Trouble sleeping, insomnia

- Personality changes
- Childlike behavior
- Anxiety
- Depression
- Irritability
- Anger issues
- Mood swings
- Increased aggression
- Double vision
- Sensitivity to light and sound
- Post-traumatic stress disorder (PTSD)

But even after reading the article, and seeing the list of all the side effects, I was not prepared for what lay ahead. The aromatherapy essential oil I had brought Paige from the airport seemed like it was not giving any relief for her migraines, even though our visitors and the nurses commented on how they enjoyed the smell. Nothing seemed to help. I thought that Paige should have been getting better by then. The medication should have been working. But it was not!

DAY FOUR

Nothing seemed to change for a day or so; and, if any-thing, Paige seemed to be getting worse. When I first arrived at the hospital, she seemed stable. Now, she could not open her eyes because of the excruciating pain. Paige had no energy to fight. At one point, she told me she did not know how she was going to survive the pain. It had been days since the accident, but nothing had improved. I felt like the nurses did not have much sympathy because Paige did not have a lot of visible injuries. Most of her injuries were invisible – especially the biggest one, the one to her brain.

When you suffer a TBI you **look fine.** No one can see the damage on your brain without magnetic resonance imaging (MRI) or a computed tomography (CT) scan – so they presume you **are fine.**

DAY FIVE

Friday morning, the doctors told me Paige was ready to go home. I was in shock and did not know what to say. How could they think she was ready to go home? She could not open her eyes because of the pain, and she could not walk without assistance. All she was doing was lying in bed. The only time she showered was when the nurses took

her into the bathroom and washed her. She was barely eating or drinking.

How was I going to take care of her all by myself? I had never experienced anything like this situation, so I had no idea how to handle it. I was advised that I could speak to a hospital advocate, but I did not even know the questions to ask. Paige was clearly not ready to go home, but no one would help me.

I called a few friends to see if they had any ideas about what I could say or do so that the hospital would keep her. One friend recommended that I admit Paige into a facility known for its leading-edge research with TBI patients. The facility was within driving distance and would accept our insurance. Unfortunately, they had no rooms available at that time, so I continued to search for an alternative option.

I begged for help – but everyone looked at me like I was crazy. They said there was nothing else they could do for her.

They released Paige from the hospital and pushed her out to my car in a wheelchair. I had no option but to drive back to the apartment. If I could do it over, I would have driven her to the emergency room of a different hospital. It is aggravating when you have to be your own health care advocate, especially when you are in shock and have

no idea of the magnitude of the injury or what resources are available.

The nurses and doctors are overloaded, and the insurance companies have limits on the amount of hospital care. I have heard stories from others who experienced similar situations – specifically, similar TBI situations. I have also witnessed, firsthand, other family members who were released from care too soon and left without an idea of what to do next.

I have never in my life felt so helpless. I had no idea what I was going to do when I got home. I kept thinking, *I am not strong enough to handle this situation.* I could not understand why this was happening to us. I had to find enough strength for the both of us. She needed me.

LESSONS LEARNED

This was such a tremendous learning curve for me. Here are some of the suggestions that helped me during this horrific time:

- Accept help from friends, and ask for help when in need.

- Be your own advocate, and do not be afraid to ask questions and stand up for yourself.

- Rely on your higher power for strength.

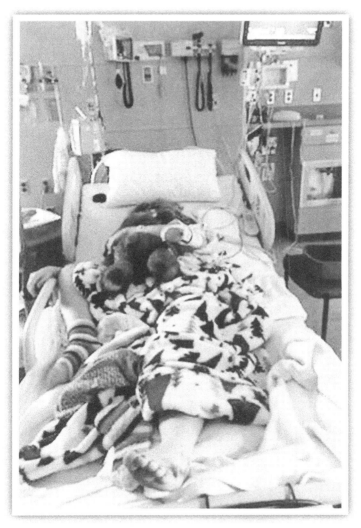

Paige in the hospital, just days after being
hit in a pedestrian crosswalk by a car.

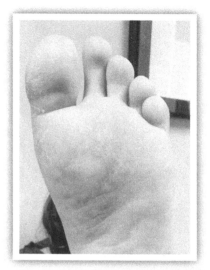

The bottom of Paige's left foot, months after the accident.

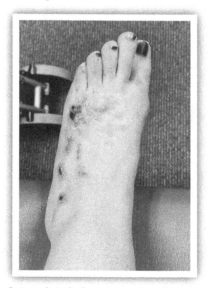

The top of Paige's left foot, months after the accident.

CHAPTER 4

NO RELIEF

The drive home from the hospital was painful for Paige. Every single bump in the road caused her to cry out in pain, even though I was driving as slowly as I possibly could. At one point, I pulled over to allow all the cars that had stacked up behind me to pass.

During the entire ride home, I wondered how I was going to manage to get Paige into my apartment. The hospital sent us home with crutches to assist Paige with getting around due to the injuries on her left foot; but, she did not have the strength to use them. It was going to be a bit of a challenge to make it through the parking lot and then up to my second-floor apartment – particularly since she could not open her eyes.

When we arrived at the apartment complex, I looked around and noticed a neighbor and his two sons walking

past. I asked them if they could help me get Paige into the building. They had no option but to pick her up and carry her into the apartment.

I was fortunate to live in a safe apartment complex that was equipped with an elevator, and I had friendly neighbors – but I wondered how I was going to take care of her on my own. Again, I wish more than anything that I would have just taken her straight to another emergency room – but hindsight always makes things clearer.

I had been living by myself for several years since my divorce. I had sold the house we had lived in for 10 years just the month before. I had given most of my furniture away, including the guest bed, when I moved into a two-bedroom apartment. The only furniture I kept was my bed and the living room furniture. The guest bedroom was used as a storage room, with boxes stacked around the whole room. Paige would have no option but to sleep with me, at least for the first night.

As soon as we entered the apartment, Paige lay down on the couch where she would stay until bedtime. She was in excruciating pain, was not able to eat, and was extremely moody. I tried everything to comfort her, but nothing seemed to help. She was angry, barely saying a word; she just lay there, unable to open her eyes. Even the slightest

noise gave her anxiety. When the microwave beeped, she would cry out in agony from the piercing sound.

I managed to get her to my bed for the evening. That night was horrible for both of us, and neither one of us was able to get much rest.

DAY SIX

The next day, a friend and her husband dropped off a twin-size mattress for Paige. We put it in the spare bedroom, in the middle of all the boxes – nothing fancy, just a mattress on the floor.

Another friend stopped in to stay with Paige, so I could pick up some essentials for that evening and her prescription medication. Luckily, Paige's pain medicine had kicked in enough so she could tolerate visitors for a short period of time. I do not know what I would have done without my friends, and I will be forever grateful for their help at that difficult time.

My parents wanted to see Paige, but when they stopped in to visit, she was in so much pain she could barely talk. She also still could not open her eyes. While they were in the other room, Paige demanded that I close her door – she said she did not want any more visitors. I walked into the living room and told my parents Paige could not handle any company. They were confused; to them, **she**

looked fine... and they just thought Paige was shutting them out.

Because TBIs are not visible, people who do not have experience with them have no idea what it is actually like to experience one. No one except Paige could understand the pain she was suffering at that time; and she herself was not even able to express it.

DAY SEVEN

I knew something was not right. As a mother, you have that intuitive feeling when your children are in pain. Paige barely spoke to me and would not let me help her in any way. We had always had a good relationship and this was not like her at all. I knew she needed more medical help. I knew I had to do something to help her – but what was I going to do?

I spoke to a nurse, who said that I should call an ambulance if Paige was still in that much pain. I decided to make the call, since I knew I was not capable of getting her to the car by myself. I was relieved when the EMTs arrived and began trying to communicate with Paige about going to the hospital. She answered a few questions, but refused to go. The EMTs explained that there was nothing they could do since Paige was of age, could sign her name, and was refusing to go.

I was mortified, to say the least. I wondered how I was going to handle her on my own, since she was so defiant and insisted on no visitors. Later, Paige told me that she refused to go because she was in so much pain that there was no way she could handle the ride to the hospital. After they left, Paige became more angry and would not even speak to me. I frantically began to devise a way to get Paige some help; I started calling friends.

I had no idea what I was going to do; but I had to do something. Finally, Paige's childhood friend, Erin, came to visit and was able to get through to her. Her friend is a sweet girl with a strong faith. Paige trusted her; and after a couple of hours talking, Paige started communicating with me again. She agreed that she needed more medical help, and promised to go to the hospital this time. Her friend was a gift from God that day, and I will forever be grateful for her friendship and ability to share the Lord's word.

DAY EIGHT

I had to be strategic about when to call 911. I had figured out when the pain medicine would take effect and would give enough relief so that Paige would consent to go to the hospital. I had a one- to two-hour window that would allow everything to work out. But just in case, I would be on the phone begging a few friends to come and help if it

was needed. I thought if I could get someone she trusted – someone who was strong enough to carry her – somehow, we could devise an alternate plan. I knew I had to get her to a doctor.

A few hours later, the pain medicine took hold, and Paige felt well enough that she said she would go to the hospital. Since I could not physically get her to the car, I had no other choice but to call an ambulance. I remember the moment vividly. She was still lying in bed when I said, "Are you ready to go to the hospital?"

She answered that she would go after she took a shower. I was not prepared for that. I knew that a shower would take at least an hour – and by then, the pain medicine would wear off. At that point, I was about to lose it! Just to have her sit up in bed and take her medicine took 30 minutes. I prayed everything would go as planned – and somehow, it worked.

After an hour or so she agreed, and I immediately called 911. They arrived very quickly. At first she seemed reluctant, but then she finally agreed to go. I was never so relieved in all my life. It was as if the biggest weight had been lifted from me.

I followed the ambulance to the hospital, and immediately went to the emergency room where they had taken Paige. Light and sound were unbearable for her and so

she was still wearing the eye patch. Paige was demanding and rude because of the intense pain, and because she had endured an uncomfortable ride in the ambulance. As soon as she saw me, she asked where her teddy bear and blanket were. They had given her security, but since I did not have them with me, I would have to go back home and get them.

It was a 20-minute drive back to the apartment. For the first time in a week, I felt at peace. It was such a relief knowing she was back at the hospital, because I knew she needed more medical attention.

When I arrived back in the emergency room, Paige was acting differently and seemed calm. It was odd. Evidently they had given her morphine, which she had never had before. Paige then told me that she did not know if she was going to make it.

At first, I thought I was going to break down, but I knew I needed to stay strong. I reassured her she was going to be OK and that the medicine was making her feel differently; but I became afraid that I might lose her. I was determined to do anything I could to get her the treatment she needed.

I frantically began making phone calls to family members and friends to try to get medical advice and support. The emergency room was chaotic and loud, which made

Paige feel worse, and made me anxious. I pleaded with the doctor on call to try and get her admitted to a different hospital. Someone had recommended I take her to the top-rated hospital in the city – in hindsight, I felt that I should have taken Paige there after she was discharged from the previous one.

We spent the next five hours in the emergency room while they did another MRI on her brain. They contacted the previous hospital to get the last MRI results, and after comparing the two, they told us that Paige's brain was swelling. It was causing her excruciating pain, and she was at risk of having a stroke. If I had not taken her to the hospital, I do not know what might have happened.

Patients with TBIs are at high risk of having a stroke or a seizure. My gut feeling – or "God feeling" – told me something was not right, so I did what was necessary to get the treatment Paige needed. You **have to be your own advocate** and keep pushing until you find answers.

After the on-call doctor relayed the information to a neurosurgeon at the new hospital, they said they would accept her as a patient. Staff from the emergency room transported Paige to the new hospital, and I drove to meet them there. They immediately took her to a room, started administering medication, and then said they were moving her to another part of the hospital.

I was impressed with the hospital and how quickly they devised a treatment plan. It just felt right and I knew everything was going to be OK. The staff was friendly, professional and accommodating; and her room was quiet with a beautiful view of the city. Paige was still wearing the eye patch, and getting her to the bathroom still took assistance; but everything felt more manageable.

DAY NINE

The following morning, the neurosurgeon stopped in to update us. He was friendly and had an excellent bedside manner. He reassured us they were doing everything they could to reduce the swelling on her brain. Within 24 hours after receiving a steroid, things began to change and her migraine started to lessen. Little by little, Paige was finally able to communicate, and took her eye patch off. God had answered my prayers.

DAYS 10 - 12

Paige continued to heal; but she also started acting very erratically – demanding and childlike. It seemed like once the swelling went down and her migraine improved, her emotions went out of control. My son Jake was visiting one day when Paige was being very demanding, and he asked why I allowed her to treat me that horribly. She was

not acting like herself at all. I tolerated it because I knew she was in a lot of pain, both physically and emotionally.

To survive, I took regular walks down the hall. But within a few minutes, Paige would call out for me and beg me to come back. It was as if she were two different people. I was so relieved that her migraine was getting better, but I wondered how I would deal with this new person.

I later discovered that this type of behavior was normal for someone with a TBI – but it was difficult to learn how to deal with such irrational behaviors. I thought to myself, *This is just the beginning of her healing, so I had better learn how to cope.* Paige's migraines continued, but were not as severe as before.

DAYS 13 - 14

After four days in this hospital, it looked like Paige was ready to be released. The ride home did not cause tremendous pain like the first time, even though she still yelled at me to slow down and avoid bumps. I borrowed a knee-wheeler from a friend, which made it easier for her to get around. I knew I had a lot more work to do around the apartment to accommodate Paige, but I was grateful to be home.

During her visits to two emergency rooms and three hospitals, Paige had over 15 CT, MRI, and X-ray scans

combined. Her brain was the number one concern, but she also had injuries on her neck and back, her left leg, and her left foot, which was miraculously not broken.

I was happy to be home with Paige. But I wondered what would have happened if I had not insisted on taking her back to the hospital. Why did the first hospital release her so quickly? Why did we have to go to two emergency rooms and three hospitals?

Little did I know at the time that all of the pain that resulted from the damage done to her body would eventually lead to deep, chronic anxiety and depression.

LESSONS LEARNED

- Patience is of utmost importance when you are the caretaker for a TBI patient.

- Surround yourself with supportive friends and family.

- Educate yourself about TBI and know that just because they **look fine** does not mean they **are fine.**

CHAPTER 5

TIME TO HEAL

I thought that when we returned home we would be able to go on with our lives, since Paige was out of danger; but little did I know the healing process was only just beginning. I was unaware of the other issues that would soon surface. Depression is common for those with a TBI; as is anxiety, moodiness, post-traumatic stress disorder (PTSD) and extreme fatigue.

Paige slept most of the time and became depressed. She secluded herself from everyone – including me. I wanted to help her, but there was nothing I could do. I made every attempt to cheer her up, which included bringing her little surprises – but nothing helped. She stayed in her room all of the time, and only came out to eat or use the bathroom.

I knew it would be a tough transition for both of us; but it was worse than I expected. Although I knew – intellectually – all that a TBI entailed, I did not understand it emotionally. It felt like I was walking on eggshells most of the time. Paige's depression continued to worsen, and I was concerned about her emotional state. She became quiet, introverted, angry, adolescent, and tired all of the time. This was exactly opposite of the old Paige, and I was confused about the changes. Would they persist? Would she get back to her old self? If so, when?

No one had any idea what we were going through. How could they? Even I did not understand what was happening. I did not have anyone to confide in. I felt that if I told anyone about Paige's behavior, they would presume she was acting like a brat, or that I was just complaining too much. Was I being too gentle on her? Was I tolerating laziness when I should have been pushing her to get out of bed and get back to her life? These thoughts confused me. There is so little understanding about TBIs, and no one prepared us for what was ahead. I had to go back to work, and I was actually glad about that; but I also worried about leaving her alone.

Paige's life had changed so drastically – she had gone from living in an apartment with a friend in her college town, with her own bedroom surrounded by all of her

belongings – to living in a room with boxes and a mattress on the floor. It was almost impossible to get her out of the apartment. Thankfully, she would soon start therapy, which would force her to go out.

I had been advised to find a support group for patients and caregivers of TBI. The group helped me to understand the emotional and physical pain she was experiencing. Listening to the personal stories from other TBI survivors, with the pain and anguish they experienced on a daily basis, was eye-opening.

I came to understand that Paige was not just being unreasonable and difficult. It was helpful to be around others who were dealing with many of the same issues – it allowed me to become a better caretaker. I did not feel alone anymore. I highly recommend joining a support group for any difficult situation you are going through.

Many TBI survivors can be accused of being lazy, moody and irrational. I learned that it is normal for caregivers to misread the actions of their loved ones. It must be so frustrating to the patients. I also learned that setbacks will most likely happen. We do not know what challenges people have in their lives, and we have to be empathetic and understanding. I was learning how to care for a child with disabilities for the first time.

The personality changes created the most difficult challenges. One minute, Paige would be sweet, loving and helpful; other times, she was quiet, irritable and defensive. Her personality changes are still extreme from day to day. In the first year or two after the accident, I took it personally, as if she was upset with me. Now that I understand her injuries, I realize that when she is quiet or irritable, she is in pain.

Prior to the accident, Paige was an energetic, hard-working college student, living her best life. She was attending the University of Cincinnati – working, exercising, volunteering, grocery shopping, making meals, and attending social activities. She was happy, energetic, helpful, lovable and healthy. After the accident, her personality completely changed. Paige became quiet, introverted, depressed, angry, extremely fatigued, irritable, childlike, emotional and moody. The first year was the worst.

Paige still suffers from most of the symptoms above, and she may do so for the rest of her life – it is an ongoing learning process for the two of us. A TBI does not just disappear like a cast does when it is removed after a broken arm has healed. It has a long-lasting impact that is often easy for outsiders to forget because the TBI sufferer **looks fine.**

MEDICINE AND NUTRITION

All of the medication Paige had been taking – along with her limited mobility – caused her to gain some weight, which led to her feeling even worse about herself. We learned that the side effects to many prescriptions can outweigh the benefits. Taking prescription medicine was essential at times for Paige. But we learned to understand what she was taking – why she was taking it – and what the side effects could be, so that we could make the best decision for her situation and her body.

We also learned that nutrition plays a huge role in recovery from a TBI. Thankfully, Paige had been in good shape before the accident, and was eating a plant-based diet. The year prior, I began my health journey; and since Paige was already vegetarian and plant-based, I decided that I would start eating cleaner. Changing my diet made me feel better and helped me become a better caregiver. A plant-based diet helped Paige get back on track; it helps reduce inflammation, increases energy, and improves overall well-being.

At a young age, I had learned how to cook from my mom. It was natural that I would teach Paige how to cook at a young age as well; we both enjoyed cooking. Paige continued to cook during college while most students

were eating out. She enjoyed being healthy, so she knew she had to prepare her own food.

So we began preparing meals and cooking together; learning new recipes with ingredients that would help in her healing. But as in everything else, Paige had challenges. She had to learn how to adjust to her new reality. The TBI had caused her to lose her taste and smell, and it still is not quite the same. She could not smell smoke at all, and she burned food again and again on the stove as well as in the oven. She set the fire alarm off at least a dozen times. She even broke one of my stoneware dishes in half when she left it in the oven too long, and it caught fire because she did not smell the smoke soon enough.

A NEW REALITY

Paige was in her last year of college, but had to withdraw from school, quit her job, and live with me. She lost her independence. When we came home from the hospital, she thought she would only be staying with me for a week; but we soon saw that she needed my care.

No one could begin to understand the hell in which she was living. She was pissed off at the world – and the effects of her injuries were just beginning to appear. I cannot even describe how angry she was. She wanted her old life back; she kept saying that over and over again,

begging God to reverse all of it. I wanted my life back as well, and was struggling with our new reality. Paige missed her friends, and we both wondered how long the misery would continue.

Paige began physical therapy to try and repair the nerve damage done to her left foot. Since she could not drive, my parents took her to appointments when I was working. They were so helpful during that time, and I am so grateful my parents are healthy – my dad was still working at the age of 81! I love my parents dearly and am so thankful to have them in my life.

I knew that getting Paige out of the house to go to physical therapy would be beneficial in many ways – especially socially. She made friends with her therapists and looked forward to seeing them three times a week for the first few months, and then regularly for a year. Paige still gives them credit for saving her life, because they gave her something to look forward to when she felt like her life had ended.

During Paige's physical therapy appointments, they focused on several things: the nerve damage down her left leg and into her left foot; the disks protruding in her cervical and lumbar areas; the post-traumatic arthritis in her lumbar region; and the chronic, full-body pain. They also conducted vestibular therapy for her balance and her

migraines. She was at physical therapy for hours at a time, and every visit had homework. She also had dry needling on her back towards the end of her therapy – a form of treatment using needles on trigger points.

Within a few weeks, Paige was able to put more pressure on her left foot and began moving around a little better, which meant she was finally cleared for driving again. Paige was very hesitant to get behind the wheel of the car. I understood why she was so apprehensive, but the longer she waited, the more difficult it would be. Still, if she would have said she was not ready, I would not have pressured her.

One day while getting in the car, I told her maybe it was time for her to try driving. She was so scared – but she got in the driver's seat and did just fine. She was nervous, but calmed down soon enough. To this day, she is calmer while driving than in the passenger's seat. I believe it is because she feels more in control, and she does not get as nauseated. Still though, whenever it is raining and dark out, Paige has a lot of anxiety, because her accident happened under those conditions.

After many X-rays and physical therapy appointments, the doctor diagnosed her left foot as having sustained some permanent nerve damage. He explained to Paige that she might not be able to run again; but thank

goodness she was able to walk. We also were told that other activities that she had enjoyed, like snow skiing, ice skating, and riding roller coasters might not be possible anymore because of her TBI. We did not know what other activities might be limited, down the road.

After graduating from therapy at the first location, she went on to see another specialist in dry needling, who included transcutaneous electrical nerve stimulation (TENS) in the therapy on her foot. This combination of dry needling and TENS was very painful.

I think one of the reasons Paige has healed as much as she has is due to her dedication. She has always been this way. During grade school, she earned good grades; at the same time, she participated in a number of sports, was involved in music, and still made time to socialize. She went to the same school for 12 years and knew everyone well because she liked having lots of friends. Paige was even a member of the homecoming court in high school.

THE SEARCH FOR A DOCTOR

Paige still has issues every day, suffers chronic pain, and is limited in her activities. I try to find the silver lining in every situation, even when things seem at their worst. The neurologist from the hospital said we would need to find a new neurologist and develop an ongoing treatment

plan. He did not provide us with any recommendations, so we had to search to find a replacement.

This remains a huge issue. I have taken Paige to numerous neurologists, but we still have not found a satisfactory doctor. I have heard many TBI survivors express the same concern. One doctor started writing prescriptions before she looked at the MRIs. I have even reached out to the Cleveland Clinic and Mayo Clinic.

Ohio State University's Wexner Medical Center has an excellent program for TBI survivors, so we made an appointment and started therapy right away. Prescription medicine is necessary a lot of the time; but the side effects of long term use can cause more damage than good, so we began to explore other treatments. Paige began vision therapy to help with the cognitive effects of the damage to her brain. We believe that vision therapy and vestibular therapy have played a significant role in her healing.

Paige suffered no broken bones – everyone thought she **looked fine** because her injuries were, for the most part, invisible. As her caretaker, I could see the daily pain and anguish she suffered. Some days, just getting out of bed was difficult. Paige would wake up in the late morning or early afternoon, walk immediately to the bathroom and take a shower to wake up enough to face the day. Next, she

would go to the kitchen and make a cup of coffee. Then, she was able to communicate.

As I write this, almost three years later, the same is still true. Paige went through a major depression the first year – and also experienced PTSD and anxiety, which can be typical for a TBI survivor. To those around her who were unaware of all this, it was confusing and aggravating. Although I had read information about the after-effects of TBIs when I was at the hospital, nothing could have prepared me for what lay ahead. This is why we are writing this book – to help those who have a TBI, and those who love and care for them, better understand what a TBI can entail.

The fatigue continued for months; and three years later, Paige still struggles to get enough rest. Many TBI survivors, including Paige, suffer from insomnia, which makes matters worse. It is also normal for a survivor of a brain injury to have mood swings and a change in personality, as I noticed with Paige. She was very demanding at times, especially right after the accident. To deal with her mood swings, I walked away when she was demanding or rude, so I would not have the opportunity to react. I learned to be more patient and to give her space when she needs it – and I still do that today.

It was difficult at times to not take her behavior personally; but I knew it was caused by the brain injury. The accident changed Paige, and I was not sure if I would ever get her back. I was certainly grateful that she was still here, and was not injured more seriously, but it was difficult.

I kept hearing the saying, "God does not give you more than you can handle," but I have never been able to handle tough situations very well. My grown-up daughter became a 22-year-old child much of the time. I am not the most patient caretaker; but I did the best I could because my daughter needed me. Still, I wondered how much more I could handle.

LESSONS LEARNED

- Everything happens for a reason, and you learn from your mistakes.

- Alternative therapy is always an option to medications.

- Try the thing you fear, and you may find that it is not as scary as you thought.

CHAPTER 6

THE VOICE

When Paige was 18, I bought her a guitar for Christmas. She was excited to start creating her own music. Ultimately, with the pressures of college and working, the guitar stayed in its case. Paige had every intention of taking guitar lessons online, but it was more difficult than she thought.

A few weeks after the accident, I came up with what I thought was a great idea. Since Paige was not very mobile and her depression was getting worse, I thought she needed something fun to do. After moving the rest of her belongings to my apartment, I saw the guitar sitting there, so I asked her if she wanted to take lessons. She was excited and nervous, but jumped right in.

Since Paige was not driving at that time, I took her to her first few appointments. She was anxious to get started,

but a little embarrassed because I had to drive her. It was good for her to get out of the apartment, but difficult for her, because she had lost her independence.

It was a good experience; but after a few weeks of frustration, Paige decided the guitar was not for her. Singing has always been her true passion. Her voice is her instrument. With so much time on her hands, Paige began writing poems and turning them into songs. She told me she had been writing poems her whole life, but never realized they could be songs.

One of my clients, a vocal coach, was kind enough to agree to work with Paige in his studio to strengthen her voice. Music therapy has been known to improve cognition, boost muscle control, and aid patients in regaining speech skills lost from a brain injury. Music also engages different areas in the brain at once, which improves overall brain function. Paige had been practicing on her own, but the vocal coaching sessions were exciting, and they motivated her to continue.

Going to the studio and singing was the one activity that gave Paige happiness. Even though she had been singing her whole life, her voice did not sound the same at first – I presumed it was because of the accident.

It was also good that Paige was getting out of the apartment and communicating with other people. I could

tell she was becoming more passionate about singing; she recorded "Stay," a cover version of a song by Rihanna. That helped her prepare for the next step she was about to take.

Paige deleted her old social media from before the accident, and started new Instagram and Facebook pages called Paige's Vocals (@paigesvocals). She then posted videos of herself singing cover songs of today's hits. She also created a YouTube page called Paige's Vocals. On that platform, she posted videos of herself singing cover songs a cappella. Her first post was of the traditional Christmas song "What Child Is This," based on the version by Bing Crosby.

At first, Paige gained an online following that consisted of only her family and friends, but soon others were supporting her, too. She received a few negative comments in the very beginning, and still does occasionally today; but she does not pay attention to them. She never engages with those people, and never deletes the comments. I think this is a wise skill to develop for continuing in a singing career.

About six months after the accident, Paige told me that she wanted to try out for the TV show, *The Voice*. Of course I supported her, and told her I would be happy to drive her to Nashville for the audition. I hoped that entering the competition would help Paige with the depression

that had plagued her since the accident. What better way to help her through a tough time than helping to make a dream come true?

It was a difficult time for the both of us. Paige had been healing and was getting around better, but the depression was getting worse. We both needed something to look forward to, and Nashville sounded like a good idea. *The Voice* would be a good opportunity for Paige to develop her vocals and explore any future opportunities. I thought that everything would be fine on the trip, since it would be a short one.

I knew that driving would be easier on her than flying, so that is what we did. But the drive to Nashville was stressful. I had to work on the day we were supposed to leave, so we did not leave until late afternoon, and it was a six-hour drive. Since Paige was not driving yet, I had to get us there. It was rainy and dark, and we had to drive through the mountains.

By the time we arrived in Nashville, I felt my vertigo coming back due to the anxiety of the drive. I have positional vertigo in my left ear, so I cannot lay on my left side or flat on my back. I also have to be careful turning my head from side to side. And, air pressure (related to changes in elevation) significantly increases the chances of vertigo.

My worst experience with vertigo had once left me debilitated for weeks – so I was cautious. Another experience with vertigo in the past left me unable to move my head. This time was not quite as debilitating, although I did not get much sleep that night. I felt nauseated and had to sleep sitting up.

The Voice tryouts were held the next morning, and Paige was excited and nervous. After my shower, I went to the lobby so she could have time to practice alone. Paige had decided to sing "Amazing Grace," which I thought was appropriate for her considering all she had been through. She had practiced it over and over for about a month straight.

I met a friend who lived in Nashville for lunch. I was excited for Paige, but I was not feeling my best due to the vertigo. Paige called me when the audition was over and filled me in on the details. She was not chosen for a callback, but she said she had learned a lot from the experience and met some new friends. She told me that no one in her group was chosen for a callback.

Paige also said that the person who made the decisions on who would make the cut for the show looked around at the end and said she had some hope for a few in the room. If they would keep practicing, she said, they could make something of themselves.

Paige knew she had potential. The experience taught her where to focus – and she was determined to continue singing. I believe there is always a lesson to be learned; and it is always a good idea to step out of your comfort zone. We both learned from that weekend. I know that stress and anxiety caused my vertigo, as it had done so in the past. Today, I am better at dealing with stress and anxiety because I am growing stronger in my faith.

Paige returned home and kept writing, singing, and moving forward with her music. Maybe her commitment to music was one of the gifts of the accident? Paige turned to singing out of desperation and frustration and boredom, which she would not have experienced if she had still been living her life in college. The accident was a blessing in disguise – it helped Paige find her true passion.

LESSONS LEARNED

- Find new hobbies that excite you, or revive old ones.

- Incorporate music into your life to stimulate your brain.

- Look for opportunities to grow, even when things do not work out as you had hoped.

CHAPTER 7

INVISIBLE INJURY

I cannot tell you how many times since the accident I have heard people say, "She looks fine" when talking about Paige. Nor can I imagine how many times Paige has heard it. A brain injury is internal – and therefore, unseen. Paige not only suffered a TBI, but also additional invisible injuries; so, it has been difficult for people to understand her situation.

For example – one day, Paige returned to the apartment complex after an appointment with the doctor. Paige was able to walk on her own without the knee scooter, but she walked with a limp. She had a temporary disabled sticker, so she parked in one of the disabled spots. After getting out of her car at our apartment complex, someone nearby

made a comment to her about not looking injured. Paige was hurt and offended, but did not respond. Not only was she physically injured, but she was also going through major depression.

We do not know what others are dealing with on a daily basis. It is not our right to judge others. Maybe you have dealt with something similar; I am sorry if you have. If we all were a little more compassionate, the world would be a better place.

I believe that feelings and energies that you send out will come back to you. On my part, I will continue to do my best to be more compassionate and understanding to others. I hope you will do the same.

UNDIAGNOSED

As time went on and Paige continued to have symptoms, we learned about something called post-concussive syndrome (PCS). The majority of concussion symptoms will resolve within about two weeks. In cases where symptoms last longer than a couple of months, doctors may issue a diagnosis of PCS. I had never heard of PCS, nor had any doctor ever mentioned it to Paige during her 300-plus doctor visits. We had to discover it on our own.

PCS is the persistence of symptoms lingering beyond the normal recovery from a concussion or

TBI. These symptoms can include headaches, fatigue, vision changes, confusion, insomnia, and difficulty in concentrating. PCS is more common with people who have experienced multiple head injuries.

Patients with PCS can experience concussion-like symptoms at rest, or in response to too much physical or cognitive activity. PCS often forces them to withdraw from their usual physical, professional, and social lives. The symptoms can be minor and come and go, or they can become a way of life, as they have with Paige. She has had multiple panic attacks, which caused her whole body to break out into a rash. The panic attacks have also made it difficult for her to breathe, which required that we rush her to the emergency room. I believe that Paige's episodes of panic attacks come from anxiety, depression and PTSD.

More than likely, there are thousands of people who have suffered a TBI but have never been properly diagnosed. After hearing stories from many of my acquaintances who experience issues similar to Paige, I asked if they ever had a concussion – and most of the time, they have. I am not in the medical field, and I do not give others medical advice, but I often suggest to these people that they do their own research after sharing TBI information with them.

Every case is different – and very difficult to diagnose – because no two people are alike. Nor are two brain injuries the same. Studies have shown at least 5 to 10 percent of the population has suffered from a brain injury; many have not been diagnosed.

FINANCIAL STRESS

I cannot imagine the pain Paige deals with everyday – but I will tell you, she is one tough girl. She does not complain much; but I know when she is hurting because she is very quiet, moody and withdrawn. During her recovery, Paige spent most of her time alone in her room. As a mom, there is nothing more difficult than seeing your child in pain; and I would have done almost anything to make her feel better.

After taking a semester off due to the accident, Paige was able to finish college with the help of disability services. After graduating with a bachelor's degree in health promotion and education from the University of Cincinnati, I told Paige she needed to find a job, even if it was part time. She seemed to be doing a little better, and I thought it would be good for her to get back to work.

I was not making enough money as a hairstylist and had no help financially. Our salon was closed for months;

and I am embarrassed to admit it, but I was completely broke. To top that off, I had just lost my medical insurance.

I spent the rest of my savings on Paige's recovery and was not in a good place. I felt like a total failure. I was holding everything inside. I tried to act like I was OK, but I was not. I remember walking down to the river and completely losing it. I hated myself for getting us into this predicament. It was one of the worst days of my life. That day, I vowed I would do whatever it would take to get out of the hell we had been living in – I would never allow myself to be in that kind of financial mess again.

I did not know what to do and was too embarrassed to ask for help. But if I did not do something, we would not be able to pay the bills. I had no choice but to call my parents. They have always been there for me, and of course they said they could help. I was grateful, but thoroughly angry at myself. I wanted to be independent and get us out of the situation myself, but I did not know how.

Paige found a job at a nearby gym working the front desk and selling memberships. The job was part time and did not sound too physical; but it actually did take a toll on her physically and mentally. She would come home from work exhausted and in pain. I felt horrible for asking her to get a job, but I felt like I had no other option; and I

thought it would be good for her to get back to some sort of routine.

I spent the next few months trying to get my life back on track. Between working and going to the gym, I tried to distract myself. I kept busy and tried to avoid dealing with Paige's situation. I thought perhaps she would get back to her normal self as time went on. Paige needed medical attention; but we had no insurance, which meant she could not see a doctor unless it was an emergency.

After a brain injury, most of the healing occurs during the first year. Paige had hundreds of therapy appointments, and it had been more than a year; but she still had issues. I realized that she might never fully heal.

It was such a difficult time for the both of us. I did not think she was taking proper care of herself. She needed help, but was so angry that she slept most of the time. Of course I was there for her if she needed me; but when I tried to help, she resisted. Paige was withdrawn and just trying to get by, one day at a time. Nothing made sense. I thought she should be feeling better by then, but that definitely was not the case. She was moody and irritable one minute, sweet and innocent the next. It was like she had a split personality.

I will be the first to admit that I do not have a lot of patience, and I have never been good at handling difficult

situations. I wanted her to be OK; but she was not. Of course she wanted to get on with her life; but she was still recovering. She was looking better – I would even say that she **looked fine** – but she was **not fine.** I became more frustrated as time went on. I just wanted answers.

A VACATION AND A REALIZATION

We had the opportunity to go to Florida for a few days – for next to nothing – so we went. We thought it would be a good break from everything. I was fortunate to spend a week by myself before Jake and Paige joined me. I took advantage of that time, reflecting on my life while journaling, reading, meditating and doing yoga with the soothing waves on the beach as my soundtrack. I did not turn the television on the entire time I was there – and I felt completely relaxed and at peace.

It was the first opportunity since Paige's accident to get away by myself for more than a couple of days. I needed that time and space desperately. I was grateful for the time of solitude – a time when my true healing began.

I picked up Jake and Paige from the airport and drove directly to a cute restaurant on the beach. I noticed that Paige looked really tired and in pain – I could see it in her eyes. The flight had taken a toll on Paige and she was

not enjoying the trip. She was completely exhausted and barely made it through dinner.

We drove to the condo to rest for the evening even though it was only 7 p.m. They were only there in Florida for a few days, and Paige needed extra time to rest every morning. This was when I realized that she was still not OK. I knew she needed help, and I promised myself that when we got back home, I would do whatever I could to help her heal. It did not matter to me what it would take – I was not going to give up.

FINDING HEALING

The week following our trip, we scheduled more doctor appointments and MRIs in hopes of receiving some answers. At that point, Paige already had over 30 X-Rays, CT scans, and MRIs. I took Paige to the MRIs, and even though it was a challenge for her, she did not give up.

I do not know how she made it through. I kept telling her it was OK if she needed to come back at a later date to finish the rest of the MRIs, but she knew that if she did not do them that day, she would not be back. As I sat in the waiting room, the noise coming from those machines was horrible. Paige is one of the strongest people I know, but the tests were wearing her down; I wondered how much more she could handle.

It was at that point that I started extensive research on holistic healing and proper nutrition for TBIs. Once I began searching, I could not stop. One article led to another – and during those discoveries, I knew I would find a way to share the information with others.

I bought a red-infrared light panel for at-home healing, studied oxygen therapy, and researched the best supplements for brain injuries. We had been eating a plant-based diet; but after learning more about nutrition, we started eating cleaner and preparing most of our meals at home.

> *Between 80,000 and 90,000 of people who suffer traumatic brain injuries each year develop long-term disabilities related to their TBI. Many others suffer from a variety of long-term, problematic symptoms that continue to interfere with their lives. When they try to get help for these issues, they are often told there is nothing more that can be done – or worse, that there is nothing wrong with them at all.*
>
> – THE COGNITIVE FX BLOG, ALINA FONG, PHD

WHAT WE DO NOT SEE

Paige still struggles – and maybe will always struggle – with people not understanding her invisible injury. Of course, social media does not help, because most people choose to post pretty pictures and positive quotes – not posts from the days that are challenging.

Paige is a pretty girl with a friendly personality, so her appearance makes it difficult for others to believe she is suffering or in pain. She does not complain much, and rarely discusses her accident with anyone. As a matter of fact, most of the time in public, Paige will have the biggest smile on her face and **look fine.** I admit that it is difficult to see her injuries; but if you are around her long enough, you will understand the pain she is dealing with on a daily basis.

On the days she feels good, she spends time writing and composing music to create songs. The songs either come from experiences of her life or have fun lyrics that tell a story. I would call her talent a gift from God.

Right after the accident, Paige began writing. Then she told me the title of her first album and I knew how serious she was about a singing career. I was skeptical for a long time – but somehow, everything kept falling into place. Paige started researching how to copyright a song, along with how to add it to a platform. She researched

and prayed about it; and then everyone and everything she needed kept showing up in our lives – the vocal coach, recording studios, etc.

When Paige recorded her first single, everyone had the same reaction: "Wow! She's doing great!" But what they did not see was the exhaustion after a few hours of singing, and how it took the whole next day or two for her to recover. What we see on the outside does not show what is on the inside. Paige has had to turn down many offers for singing gigs, because her body is not capable of performing for a long period of time right now. Hopefully, as time goes on, Paige will continue to heal, allowing her to do more of the things she loves.

Invisible injuries come in many forms. I have met people who were in a lot of pain, but seemed perfectly fine because they were friendly and upbeat. A close friend of mine has suffered from major back and neck issues for years and has had multiple surgeries – but never complains. I know others who have suffered from severe migraines for so long that they have given up hope and accepted it as a part of their life.

There are many people walking around with physical and mental issues that are invisible to others. They either choose to hide their ailments or decide to think positive thoughts in hopes of healing. Thinking negative thoughts

will only bring more **dis-ease.** I try not to complain or speak negatively, because I know it will only bring more negativity. I also encourage others to look at everything in a positive manner – positivity can help you heal.

I have shared our story of TBI and PCS from the perspective of a mother and a caregiver – but no one can explain what it is like as well as the one who has lived it. So, I have asked Paige to share her story from her perspective. I hope that you will find inspiration and education in the following pages, as Paige pulls back the curtain for the first time and takes you into the world of someone who is living with an invisible injury.

LESSONS LEARNED

- Many injuries and illnesses are invisible.
- Try to speak and act in a positive manner.
- Taking time to unplug from the daily chores of life can benefit yourself and everyone around you.

PAIGE

CHAPTER 8

THE ACCIDENT

At 22 years old, I was an independent young adult, putting myself through college, living a life full of school, friends, work and fun. But on September 9, 2018, my life changed – and the life I knew ended.

I was walking in a crosswalk when a car hit me from the right, causing me to fly onto the hood of the car and then smash into the pavement. The front of my head hit the windshield, the back of my head hit the concrete, and my skull cracked. Of course, I do not remember any of it; this is just what I have been told.

When I arrived at a nearby hospital, I was in so much pain that I just lay there with my eyes shut. They did many scans to assess my injuries and gave me different types of medication, including narcotics and opioids, but nothing helped. I felt like I was going to die.

My best friend tried to comfort me and reached out to my family, friends, and college professors. My mom, the only parent in my life, was in California, and so we called her to tell her that I had been hit by a car.

My only sibling, Jake, who is two years younger than I am, suddenly showed up in my room along with my dad (with whom I have no relationship). I cannot remember anything anyone said to me then; and I hardly remember my best friend spending the night with me that first night.

TRAUMATIC INJURIES

Once I was assessed, the doctor told us that I had sustained a skull fracture with a TBI. I also had an occipital condyle fracture (which can cause severe disability), and an epidural hematoma (which often requires surgery), as well as bifrontal and temporal contusions (which can lead to rapid deterioration and often require surgery to remove). Lastly, I had a fourth ventricle compression (which can cause severe cranial nerve dysfunction and balance issues).

The police report said that I had been unconscious for up to 30 minutes after I was hit. My brain was bruised, swollen and had blood on it, which explained why my head was pounding and why I could not see, hear, or focus well. I had such extreme neck and back pain that both

sitting up and lying down were uncomfortable. My left foot was bruised, covered in blood, and swollen to at least twice its normal size. As I began to recover, I had to walk with the help of at least one person, and use a gait belt and crutches every time I got up.

I was lucky to be alive – but in some ways, I felt like death – or worse than death. Eventually my mom arrived, and found me in the neurosurgery unit. I was glad to see her and have her there with me. She started doing everything possible to make me feel better. She questioned everyone, used aromatherapy, and helped me walk, eat, and bathe.

My mom and I had a good relationship while I was growing up, even though we went through some really tough times. We became closer after I left for college and matured, even though we had both been busy. We were proud of each other and what the other was accomplishing.

In the few days after the accident, other family and friends visited me, too. The first few nights, I was heavily sedated and able to handle conversations; but after that, I was just lying in the hospital bed. It must have been hard for my visitors to see me like that. While it was nice to know that my family and friends cared about me, having visitors had to stop. I could not have a conversation, and

no one seemed to understand the amount of pain that was in my head.

A LIVING HELL

After a few days at the hospital, I was worse. It felt like my brain was going to explode out of my skull, and I was experiencing fogginess, dizziness, vomiting, exhaustion, and sensitivity to light and sound. I could not take my eye mask off, and my neck and back were killing me. I needed assistance with eating, going to the bathroom, and showering. I ate when they told me to eat, and bathed when they told me to bathe. All I did was sleep, and every time I woke up, I was disoriented.

On day five, the nurse told my mom I was going to be discharged. What?! I was still in excruciating pain, and could not take off the eye mask. I still could not walk or bathe myself alone. My mom told the staff that she was concerned about how she would care for me with no medical experience, and she fought for me to stay in the hospital.

They put me in a wheelchair, took me to my mom's car, and discharged me anyway. I was not doing well while at the hospital – so why was I being discharged? I needed medical care – desperately. How could a person in need

of medical care be sent home? The problem is that TBI is not well understood, even by medical professionals.

The ride home was hell – every single bump on the road made my head pound more. After arriving at my mom's place, she had to find a way to get me to her new apartment on the second floor. A few men ended up carrying me up to a place I had never been.

MORE HOSPITALS

I felt like I was going to die. All I could do was lie down with my eyes shut and then sit up every hour to take my pills. I was in excruciating pain, and needed total silence. It was like a dream – or a nightmare. I do not know if I ate or showered.

My mom was so worried that she called an ambulance multiple times to take me to a hospital, but I refused to go. I was in so much pain that I could not move. Eventually, I finally agreed to go, and the ambulance took me to the closest emergency room. It was another painful ride.

After arriving, I was put on morphine and more opioids; but those medications did not help my pain – it just made me nauseated and delirious. Between the pain I was feeling and the hell I was seeing, I was sure I was about to die. My mom comforted me and eventually calmed me down.

Scans showed that the swelling in my brain had increased. Swelling following a TBI can easily lead to death, so the doctor called another local hospital, one that specializes in neurology. A neurosurgeon there accepted me as a patient, and I was transported in yet another ambulance.

PROGRESS

After arrival at the new hospital, I had more scans done on my head and body. The neurosurgeon wanted to get the swelling down; brain surgery would be a last resort. He altered my medication list, and told me to rest and sleep.

A few days passed and I felt more awake. I was able to take the eye mask off and open the blinds. I was communicating more with the staff and with my mom. I still had a pounding migraine and body pain, but the swelling on my brain had decreased.

I could hardly move my back or neck. The nurses started to address my other injuries; I had bone bruising on my left foot and I was sized for a protective boot. I used a walker to walk up and down the hallway, but every step hurt my foot.

I only had a few visitors at this hospital. And after a few days, the nurse said I was going to be discharged. I was in so much pain and was not sure if it was time,

but I did feel better than before. The staff and my mom established therapy plans for me, put me in a wheelchair, and off I went.

MY NEW HOME

Once we arrived back at my mom's apartment, I fell into a deep, dark pit of despair. I was in constant physical, mental and emotional pain. Just two weeks before, I had been living the life of an average 22-year-old – attending college classes, waiting tables, working out, and socializing. I was a hard worker through college and paid my rent by earning money at work. I had lived on my own for four years, but the TBI from the horrific accident meant that I needed constant attention. It was devastating.

The next few months were very hard on my mom and me. I almost gave up on everything. I had been through a lot in life thus far, but nothing had prepared me for this. I still had hope in God – but my faith had been shaken.

LESSONS LEARNED

- Your life can change in a blink of an eye.
- If you are hurt, seek medical attention immediately.
- TBI's are not well understood, even by medical professionals.

CHAPTER 9

YEARS ONE AND TWO - ISOLATED

In the beginning, I was tired all of the time, and I rested or slept around the clock. As time went on, it became harder to fall asleep, and harder to stay asleep. I had a constant migraine, even while sleeping – and I had nightmares. I was in pain; but instead of taking pain medication, I used as many alternative therapies as I could. I used lavender oil for relaxation and eucalyptus oil for migraines. I had a heating pad for my back, and a cold press for my head.

I stayed in my room all day, and only came out to use the bathroom, eat, or bathe. This routine made my anxiety, depression, and PTSD worse. I completely isolated myself, even from my mom, who did everything she could to cheer me up – but nothing worked.

With isolation as my reality, I became very lonely and even had suicidal thoughts. It felt like I had no one to talk to, since my family and friends did not know what to say (and I surely did not give them a chance to try). I should have turned to my mom, but I was hurt – so I chose to hide.

CHRONIC PAIN

A month into my recovery, I was still a mess. The pounding migraine was constant; my foot was swollen, bruised and covered in cuts. I crawled around the apartment because I could not walk, and I had severe neck pain. My mom and I took turns massaging it every day.

My brain developed a sensitivity to light and noise; I was unable to use my phone or watch television for the most part. Eventually, I learned to plan when to use electronics, based on when I took my medication. Thankfully, we discovered that glasses with blue-light-filtering lenses helped to protect my eyes.

As the months went on, I slowly grew stronger. I built up my tolerance and could spend time reading daily psalms, coloring, and writing. Journaling became an outlet, just like it had been in the past. I started my mental healing process during that time.

I started talking to my mom more and we became a team again, focused on healing my injuries. Both of us became more healthy in all ways. It was time for me to become self-sufficient so that Mom could go back to work. Knowing that, I was motivated to be well again, and used multiple therapies and lifestyle choices to help myself.

NUTRITION

Throughout grade school I made terrible food choices, but in high school I made healthy changes. Before the accident I ate healthy, clean food and prepared most of my own meals. Unfortunately, going through a trauma can bring back old habits. After the accident, while I was in and out of hospitals, I consumed mostly milkshakes and pizza. Eventually, I gained a significant amount of weight.

In an effort to be helpful, my friends talked to my mom and me about how a healthy lifestyle could help, so we decided to give it a try. Mom started making smoothies, quinoa, cooked vegetables, and other healthy foods – and we both started to feel better.

PHYSICAL THERAPY

It was nice when I was well enough to start physical therapy. It was hard, but it helped me feel better mentally, emotionally and physically. Up to that point, I had used a wheelchair, walker, crutches, and knee scooter to get around. It was encouraging to imagine being able to walk normally again.

I spent a year going to a local physical therapy center in Cincinnati three times a week. We worked on my neck, back, and left foot, and did vestibular therapy for dizziness, nausea, and vertigo. I had dry needling on my neck too. The therapists were concerned for my well-being and we became friends, which I really appreciated.

UNDERSTANDING THE BRAIN

There are so many things that are still not understood about TBIs, even by medical professionals – and it is important to find a good team of neurologists. I went to a highly-recognized neurology center two hours north of Cincinnati where the doctors were kind and helpful. The car rides never got easier, but they were worth it.

The neurologists explained why my TBI made me feel and act in different ways. It is common for TBI patients to have side effects for the rest of their lives, and a TBI increases the risk for neurodegenerative diseases.

To help my healing, they referred me to vision therapy and counseling.

I went to The Vision Therapy Studio in Cincinnati for about six months to address the migraines, fatigue, dizziness, and other issues. The therapy sessions were strenuous on my brain and eyes, and I had homework as well as syntonic light therapy at home every week. Syntonic therapy uses specific wavelengths of light to treat patients recovering from TBI. The vision disorders that were caused by my TBI were focusing or convergence problems. Syntonics helped decrease my migraines.

THE NEED FOR REST

Growing up with a brother and playing sports helped me develop a high pain tolerance. I swam and participated in soccer, basketball, softball, volleyball, female football and track. I was strong and fast and could take a hit.

In college, I stayed fit by walking to class and working out at the gym. I had more energy than anyone I knew, and often pulled all-nighters to finish up an assignment or to study for an exam. I did this while also working at least one job, volunteering, and socializing with friends.

The accident changed all of that. Now I experience fatigue and low energy, and have to monitor my body all the time. When I do not get enough rest, I am irritable or

I completely shut off. Stress can cause me to experience life-threatening hives and anxiety.

COUNSELING AND SUPPORT

For about a year, I saw a counselor in Cincinnati who had a background in trauma and TBI patients, and was a professor at a local university. She helped me create boundaries with myself and with others, and taught me the importance of cognitive breaks.

I also attended a TBI support group at the Daniel Drake Center for Post-Acute Care. After the first meeting, I realized that I had the same symptoms as the other TBI patients, and that helped me to feel connected to them. I attended the group for about six months and it was beneficial. The greatest benefit was feeling understood by the other patients; when I tried to talk to anyone else about my TBI, they said they could not understand what I was talking about.

My mom and I also joined an online support group with thousands of members for TBI patients and caregivers. Caregivers asked why their loved ones no longer acted the same. Patients asked when they were going to feel "normal" again. This group helped my mom and I understand one another's situation better. We started giving each other more grace.

DESIRE IS THE KEY

I knew I was going to have to work hard to be the same smart, athletic girl I was before the accident. In the first two years after the accident, I had over 300 medical appointments. In addition to the therapies that I have already described, I also had massage therapy, acupuncture, electroacupuncture, cupping therapy, craniosacral therapy, energy healing, and more. I wanted to heal, which is why I tried so many different modalities. I celebrated every accomplishment, and then set a new goal.

My friends and family thought I **was fine,** but it didn't matter what anyone else thought. I never complained to them, because I figured they did not want to hear it. My mom and I were dedicated to our health and well-being, and every single day we were focused on growth. That was one blessing of the accident. I became healthier than ever before. I do not know if I would have become this person if I had not lost everything and had to start fresh.

RENEWING MY FAITH

One of the things that really helped me during this healing time was my faith. The seeds of faith that were planted when I was young eventually sprouted and grew after the accident. I grew up in the Catholic church and went to Sunday school every week. After my parents' divorce, we

stopped attending church except for holidays. In college, I attended a few Masses by myself and always kept a relationship with God.

After my accident, I did not talk to God – rather, I gave Him the cold shoulder. I did not understand how something like that could have happened to me. In my eyes, I was a good person who was working on a degree in Public Health, and I did not understand why I was being punished.

Eventually, a friend of mine invited me to her church, where they had a college night for young adults. There I found friends and God again, which were both such blessings. I hung out with a few of the girls I met there; and that was the start of me having friendships again. I attended regularly for a year and renewed my relationship with God, which supported my healing.

RETURNING TO SCHOOL

After a six-month break from classes, I discussed my desire to finish college with my advisor. I had a great track record at the university – I was on the dean's list and had earned academic scholarships. I had studied abroad in Ghana, Africa, for two months before the accident.

My advisor and professors were excited that I was coming back and they were cheering for me. I was excited

to go back, finish my last year, and graduate. My advisor had me apply to University Disability Services, which was a blessing because I received extra time on my assignments and exams. School was a challenge with the constant migraine and no attention span – I cannot even remember what classes I took. I had an internship with a highly-recognized nonprofit during my last semester. I made it through my last year of classes and was able to graduate.

MUSIC

I have always had a passion for music and I love to sing and perform for others. Growing up, I took classes in hip-hop, ballet, tap, gymnastics, piano, choir and band. My friends and I would put together musical routines and skits. At home and in the car, we always played music, and I was never disciplined for dancing and singing loudly. When I was about 7 years old, my mom took me to see Britney Spears, and I have wanted to be a performer ever since that concert.

During college I knew I was destined for more; but since I was good at what I was doing, I did not try for more. My greatest passion was music; but I did not take any steps toward a career in that field.

After my accident, I started writing songs for the first time. At first, I only wrote sad songs, which painfully

moved into love songs. I saw how well songwriting was going for me, so I decided to create some social media accounts for singing. After seeing engagement on my singing accounts, I decided to audition for *The Voice* in Nashville. Mom supported me without any hesitation and made it happen. I was not fully prepared for the audition; but I am so thankful for the experience.

As time went on, I started performing covers of songs at open-mic nights. I was out of my comfort zone, singing in front of large crowds of 50 to 200 people; but I was excited about it too, and it always worked out somehow. My mom, who is always there for me, came to all of my performances.

PERSEVERANCE

The accident was a major wake-up call for me, but it took me a year or two to realize that. During the first two years of my recovery, I fell down more times than I can count. I constantly picked myself up, again and again. I truly believe my determination set the tone for my healing. I learned to appreciate every accomplishment, and developed a new attitude of gratitude. I started to appreciate the little things in life, and became dedicated to making something of myself in this lifetime.

LITIGATION

Financially, things were awful. My mom had gone back to work part-time, but her income was not enough for us to live on, let alone pay for my therapies. We were in litigation, fighting to have my medical expenses paid. We provided the other side with thousands of pages of information on the injuries I sustained in the accident; but the defending attorney just kept saying, **"She looks fine."**

The defending attorney's private investigators followed me for years. I was trying to heal; but I always felt like someone was stalking me. The deposition was six hours of me explaining the pain I go through on a daily basis, and my attorneys explaining my internal injuries. It was hard to go through all that and to not be able to talk to any of my family or friends about it.

LESSONS LEARNED

- Rest often and regularly.
- Focus on healing before everything else.
- Be grateful and count your blessings.

CHAPTER 10

YEAR THREE – NOT FINE

In the third year of my recovery, I knew I was **not fine.** I was anxious, depressed, in constant pain, and could barely make it through the day. I started to understand the severity of my injuries, and that some would be with me for life. So, we continued searching for solutions.

I scheduled MRIs of my head, cervical area, lumbar spine, and left foot. The MRI of my head was the worst experience because I was constricted in a headpiece. It made me both nauseated and claustrophobic. The added TBI scan shook the machine harder and louder. The results showed that three years into my recovery, **I still had damage in the four injured areas of my body.**

My head scan showed swelling, bruising and bleeding on my brain. It also showed encephalomalacia, one of the most serious types of brain injuries. It can lead to complete dysfunction of a part of the brain. In addition, I had lost a significant amount of brain cells as shown by an increased T2 signal within white matter.

The cervical spine scan showed straightening and reversal of the spine, arthritis, bulging and protruding disks, and disk tears in my neck. The lumbar spine scan showed arthritis in my lower back. The left foot scan showed swelling, pressure, and thickening on my foot.

I was extremely upset when I got those results. I knew I was not fine, but seeing the truth on paper was awful. The brain is the most significant and sensitive organ in the body, and mine was hurt for life. I mourned it for a long time.

INDEPENDENT MEDICAL EXAM

A few months later, the defending attorney requested an independent medical exam by a psychiatrist. That made no sense; and to this day I still wonder why they did not choose a neurosurgeon to examine me.

The psychiatrist (who had no experience with TBI or trauma patients) did a lengthy, two-day, oral and written examination. He asked me questions like, "Were you this

girl before the accident?" I said no. He asked me, "Do you think you're better now?" I said no. He tried to make me feel like I was not the girl I said I was. The psychiatrist completed his write-up with, "It is all in her head." I was disgusted.

Medical professionals who have experience with TBIs understand the symptoms that come with this life-altering injury – symptoms such as anxiety, depression, PTSD, fatigue, migraines, mood swings, dizziness, nausea, sleeping issues, and memory loss. A qualified professional would have concluded that I was **not fine.**

MORE PHYSICAL THERAPY

After the sad results of the scans, I wanted to continue building up strength and stamina in my neck, back, and left foot. I found the most prestigious physical therapy institution that my insurance covered in the area. The therapist there was knowledgeable about neck and back issues, and had expertise with nerve damage.

He did specific treatments for the nerve damage on my foot, including dry needling that was connected to electrical stimulation from my left hip down to my toes. He explained that I would have nerve damage for the rest of my life.

THE SEARCH FOR A NEUROLOGIST

We wanted to find a local neurologist who could continue my care, and my mom and I found one close to home at a highly-respected institution. This doctor asked me about my symptoms, but never looked at my new scans. She said I could benefit from taking more medication and by getting weekly infusions. I did not want to be on any more medication; I wanted answers. When we asked her to look at my scans, she did not. She did not refer me to any additional brain therapies. We were furious; we left and never went back.

We then found another highly-rated institution four hours north that offered virtual appointments. I sent my scans there ahead of time so the doctor could review them before my appointment.

Fortunately, that neurologist came prepared for the appointment to discuss my scans. He said I would have a TBI for the rest of my life. He explained that, moving forward, I would need to take the best care of myself possible on a daily basis. That would include making sure that I was getting enough sleep every night, taking cognitive breaks, eating well, staying hydrated, and having social time. He also suggested having a head MRI done every couple of years to make sure nothing was getting worse.

His recommendations were helpful, because he gave us a plan.

FRAGILE

There are many things that I once did that either I cannot do now, or are very hard to do. Before the accident, I loved roller coasters. My parents bought us yearly passes to Kings Island amusement park and we vacationed at Disney World a few times. But I cannot ride roller coasters anymore. My brain is injured and fragile; I cannot engage in any dangerous activities. If I were to further injure my brain, I could die.

There are other activities that are a real challenge for me now. People naturally become exhausted after traveling – especially by air. Imagine how much harder it is on a body that has a TBI. When I fly, I am in excruciating pain and can barely walk. The last time I flew with my brother, he asked why my eyes were so bloodshot. That is just another side effect of flying for someone with a TBI.

Before the accident, I was active and really loved to run. With the damage done to my left foot, running is not possible anymore. Before the accident, I enjoyed pushing my body to new limits; now I appreciate taking it slow with light exercise, light weights, and walking.

The hardest thing I have had to force myself to do again is walk in crosswalks. I put on a brave face and push through the pain of knowing I could be hit again – it is always a challenge. That is what PTSD looks like; and I live with it every day of my life.

WORK

After I graduated from college, my mom pushed me to get a job. I applied to multiple jobs, and chose to work at a local gym and wellness center. I liked the idea of working in a healthy environment where I would be active. I sold many memberships and was the lead salesperson in many of the months during the year I worked there.

The only thing I did not enjoy was cleaning the gym every day. I was constantly walking, and lifting, and I struggled with high fatigue and issues with my left foot. My foot turned purple and black multiple times. The management did not fully understand how much harder I had to work to do the same job as everyone else.

The plus side to working in the gym was being able to use the services for free. They had resources to help me heal. I used the sauna all the time. I did oxygen therapy, which involved light exercise while wearing an oxygen mask to benefit the brain.

FRIENDS

As time moved on, I began socializing more. I got in touch with college friends, and we picked up where our friendships had left off. I also met a lot of new people at the gym. It took me a while to feel comfortable going out for drinks again with anyone.

My new friends understood who I was and what my body could handle, because that was the only me they knew. My old friends had a hard time adjusting to the new me, and some of my friendships ended. I had a lot of people walk out of my life after my accident.

PROFESSIONAL CHOICES

Being on stage is my very favorite place in the world. There is nothing that compares to that feeling. The only problem is that it takes a lot for me, with my brain trauma and other injuries, to prepare for – and recover from – performing. The combination of loud music and flashing lights can prompt an epilepsy attack, and/or trigger my PTSD. Every time I leave a music event, I always have a pounding migraine.

It may seem odd that I have chosen a profession as bold and physically taxing as singing, but I would not change it for anything. I would rather rest most of the time in order to do what I love.

FOCUSED

After the accident, it took me a while to believe in myself. But as my mom and I started to grow as a team, it became easier to achieve more. We encouraged each other. Once I made up my mind that I was going to heal and make something of myself in this lifetime, the momentum became stronger. Recovering from trauma is different for everyone; but it is worth putting in the work to heal and create a life you love. We each write our own story; and I know that if I can do it, so can you.

LESSONS LEARNED

- Understand your injuries and do not overdo it.

- Get out of your comfort zone and socialize – it is important to your health.

- Be your own health advocate.

CHAPTER 11

LIVING WITH A TBI

After more than three years, I have learned how to live with a TBI. Brain injury recovery is about rewiring the brain, including growing new nerve cells. And the best way to grow new nerve cells is to make healthy choices in every situation. Everything in my day is strategically planned to make the most of my day and keep my pain to a minimum – especially the migranes. As the day goes on, I lose my battery power, and by nighttime I am exhausted. Here is my typical daily routine:

MORNING ROUTINE

Shower
Make coffee

Make a smoothie

Take supplements

Read a daily psalm

Write in my gratitude journal

Look at vision board

EVENING ROUTINE

Shower

Make tea

Take supplements

Heat, ice, massage

Meditate

Read a daily psalm

Write in my gratitude journal

Look at vision board

As you can see in my routine, I use meditation, psalms, a gratitude journal, and a vision board to keep me grounded throughout the day. On top of all that, I use other techniques to stay proactive in my physical, mental, and emotional health.

Some of these techniques include staying active, taking cognitive breaks, and learning to stay no. It is really important for a TBI patient to create boundaries in their life. I also focus on staying positive, and on surrounding myself with positive people.

I keep a peaceful home environment that includes plants, natural light and salt lamps. I love candles and crystals, and take baths weekly (without my phone).

HELPFUL THERAPIES

My favorite form of therapy, and the one that helps me relax the most, is massage! I have at least one massage every month. After I receive a massage I am typically sore; but following a night's rest, I wake up feeling better. I also use a massage gun at home.

Another form of therapy that has been beneficial is red light therapy and near-infrared light therapy. They are similar, and they penetrate deep into the tissue of the skin and promote healing. A few years ago, my mom bought our light panel from the best company on the market. I have no complaints – only praises.

A therapy I am able to do from the comfort of my home is syntonic light therapy. I mentioned this briefly before when I referred to my vision therapy. Syntonics heals TBI patients by restoring balance to the nervous system. I still cannot get over how fascinating it is.

HEALTHY EATING

Good nutrition is important for everyone – but especially so for TBI patients. As I mentioned before, I have chosen

a whole-food-based diet. That means consuming as much real food as possible (fruits, vegetables, grains, legumes, nuts, seeds, etc.).

Hydration is key to any healthy body, and it is specifically essential for a TBI patient. Water prevents dehydration, which can result in unclear thinking, mood swings, and overheating. My goal, every day, is to drink half my body weight in ounces.

Coffee is part of my everyday routine, and it has a purpose in my life. There is scientific data that shows that coffee can help those with a TBI see a decrease in mental fogginess. It also helps increase cognitive abilities.

MEDICINE AND SUPPLEMENTS

CBD oil has been scientifically proven to decrease chronic pain, anxiety, depression, seizures, and other issues. I try to take CBD oil every single day, because it enhances my mood, my thinking, and my physical well-being. Whenever I miss a day of taking CBD oil, I can honestly tell the difference.

I put MCT oil in my smoothie every day, because it has neuroprotective properties and helps improve cognition and memory. I also cook with coconut oil as much as possible.

Because of my TBI, PTSD and chronic pain, I qualify for a state-approved Ohio medical marijuana card. THC has helped me a lot. I try to use products that have both THC and CBD in them.

Vitamins and supplements also help with the higher levels of anxiety, depression, and PTSD found in patients with TBI. I have found that vitamin B3, vitamin B9, ashwagandha, echinacea, lemon balm, holy basil, and St. John's wort work well for me. I also take: omega-3, vitamin B12, vitamin D3, vitamin E, vitamin C, boron, zinc, selenium, turmeric, quercetin, antioxidants, probiotics, lion's mane, shiitake maitake, ginkgo biloba, PQQ, acetyl-L-carnitine and L-lysine.

SLEEP

I had hoped to have a better relationship with sleep by now, but I know it could be worse. A TBI can cause poor sleep. I try to get eight to ten hours of sleep every night; but I still suffer from an inability to fall asleep, stay asleep, and feel rested in the morning.

Before bed, I always take magnesium, which is a natural muscle relaxer and blood pressure regulator. I also occasionally take valerian or melatonin before bed when my mind is racing to help with insomnia.

I have found that using meditation in my life has so many positive effects. I always feel more calm after meditating, and I have a better relationship with sleep after meditating. My anxiety and depression decrease when I meditate daily.

PURGING

One of the best ways to move on is to purge things you no longer need. My mom and I have taken time over the last few years to go through all of our mementos and furniture. We donate items regularly. I have also organized my spaces, which leads to a better workflow. Patients with TBI typically have short-term and long-term memory loss, which is another reason to stay organized.

FAITH

My relationship with God has grown tremendously in just the past three years. I talk to God all day, every day – both out loud and in my journal. God knows me better than anyone else ever could. This strengthened relationship has helped me so much; and now I want to tell others about God. As a 25-year-old person, I see the damage that technology has done to the world, and I know that moving toward a bigger focus on God is one of the answers.

GRATITUDE

A focus on gratefulness has helped my healing so much. If I wake up and have a bad morning, it might seem like the whole day could go that way – but it takes just a second to change my mindset. I make gratitude a part of my day by speaking it out loud in conversations, and writing it down in my gratitude journal. Some days, I will write down 100 reasons why I am grateful.

WORK AND MUSIC

When I left the job at the gym, I tried bartending at a local brewery because it paid better than any other job I have had. But I was in pain all of the time, and constantly wanted to sit down. I started having panic attacks; so I quit after a few months.

Since then, I have focused on my singing career. My weeks consist of writing songs, spending time in the recording studio, doing photo and video shoots, giving live performances and networking. I am working much harder now as an entrepreneur than I ever did before – but this is my dream job.

I have released my own original music that can be bought and downloaded on all streaming platforms under my stage name PAIGE. I am currently working on releasing two debut albums this year. I have received sev-

eral music awards in Ohio. My released songs have been played on multiple radio stations, both inside and outside of my home state.

I sing a wide range of music, and I am proud of that – but my brand is focused on equality. I want every person on this planet to know they are seen. I specifically want to encourage women to know that they are enough.

I grew out of the partying phase quickly; now, I usually only go out if I am doing a show. I have to limit myself more than most other people; and since I am working so hard, I enjoy relaxing nights at home. I still talk to my old friends; but I primarily spend time with people in the music industry. I have chosen mentors who are helping me to understand the business.

BLESSINGS

When I was hit by a car, I lost everything, and my life was forever changed because of a brain injury. I am a different person now than I was the day I entered that crosswalk. This journey to health has been a million times harder than my mom or I ever could have imagined. All TBI survivors are warriors; only someone with a brain injury fully understands the truths of a TBI. That is one of the reasons that we have written this book, so that others know they are not alone.

My brain injury has limited me physically, but has opened me spiritually. The injuries I sustained took me to the edge of death – and I often wished I were dead. But they also cracked me open and made me reach for help. Even through the hardest times in our lives, God has been with us.

I thank my mom for being with me every step of the way. We have been given information on how to heal and grow in the physical, mental, emotional and spiritual realms, and our lives are much richer now because of it. It is interesting how one positive thing after another has appeared in our lives – and continues to do so. There are no mistakes. May God bless you all.

LESSONS LEARNED

- Stick to a daily routine.
- Do what you love.
- Believe in yourself.

ROBERTA

CHAPTER 12

FEARLESS

As I write this, it has been over three years since the accident. Looking back on the last few years and all that Paige and I have been through, there are times I have questioned why such a challenging thing happened to us. It has been said that when one faces a trauma in life, there is a blessing in it. I completely agree with this. I had to hit rock bottom in order to wake up. I was broken, and the aftermath of the accident brought me a new life.

Paige continues to experience many physical and emotional issues, including chronic physical pain, which limits her daily activities. At the same time, Paige is also more loving and more appreciative of life. Seeing her life flash in front of her eyes has changed the way she looks at things. She has learned that the only way to heal is to forgive and move forward.

After Paige's accident, I thought I wanted to have my old life back; but as it turned out, what I needed was a fresh start. My life had been filled with trauma, unhealthiness and self-pity. I turned 50 a few months after Paige's accident, and at that time I thought my life was almost over. I quickly realized my only option was to let go and give it to God. I grew up attending church and thought I had a good relationship with the Lord; but when I take a look at where I am today, I see how much my faith has strengthened me in the last few years.

I live life differently now. Prior to the accident, I was just going through the motions in life. I graduated from high school with a degree in cosmetology and began a full time career as a hairstylist. I was married at 23, bought a home, and had my children at 28 and 30. By the time I was 40, I was divorced and had no idea what I was doing. I felt empty and unfulfilled. The accident helped me to decide that I would do whatever it took to change my life for the better – to become fearless – and I have not looked back.

GROWING IN THE FUTURE

Paige and I both have completely turned our lives around as a result of her accident. I am so proud of Paige and the fearless woman she is becoming. She is following her true

passion and cultivating God's gift of singing. Paige has a story to tell and is telling that story through her music. She has a big heart and a gift of connecting with people.

Her voice is improving daily, and she inspires and motivates others. Maybe she would not have developed her gift for writing and creating original songs, or pursued a music career, if she had not experienced such trauma.

The accident also helped me to find my true purpose. I always knew I was meant for more; but I lacked the confidence to move forward. I had been asking God to show me my purpose in life – not realizing it was right in front of me. After searching for many years, I finally woke up. Two years after Paige's accident, I began a personal development course.

Years ago, I discovered the movie *The Secret,* which explains the law of attraction. I continue to watch it on a regular basis, especially when I am feeling unmotivated. My biggest influence from *The Secret* was Bob Proctor, a best-selling author, motivational speaker and entrepreneur.

Bob Proctor influenced me enough that I decided to take his course. During the year-long course, I learned that everything is made up of energy; and the law of attraction states that our thoughts draw energy and action to ourselves. Sounds simple, right? Yes – but no. I had to dig deep to find out who I truly was, and what I really

wanted. I had to develop my self-confidence and learn how to quiet my mind, which allowed me to imagine and focus on attracting the life I wanted. As Albert Einstein said, "Imagination is everything. It is the preview of life's coming attractions." My imagination led me to write *She Looks Fine*.

After Bob Proctor's passing in February 2022, I decided to continue my journey of personal growth and development with one of Bob's students, Kathleen Cameron. Kathleen's program and her best-selling book, *Becoming the One,* has helped guide me to a new level of healing and evolving. I am dedicated to growing and mentoring others to help them improve their lives and heal from trauma.

A STORY THAT MUST BE TOLD

One day, while meditating as part of the program, the idea came to me for this book. At first, I thought it was the craziest idea I had ever had. I thought, *How am I going to write a book?* I am not a writer, and was never great at writing papers in school. But I knew that many people needed to hear this story. If only Paige and I had had a book like this to help us through the last few years!

Due to litigation, I was not able to speak freely about what we were going through. Maybe that is why people thought that everything was fine – that Paige was fine –

that we were fine. That was not the case; we were struggling in every aspect of life, but we were not able to discuss it with anyone. During that time of litigation, I knew that someday I would be able to tell my story.

I knew I had an obligation to write this book – to do something to give back. I was so fortunate that my daughter lived, and was given a second chance at life. Day after day, I heard stories of TBI survivors and caregivers struggling to find answers. I continued to stumble upon information that I had to share.

One day, I started writing. Since I believe in the law of attraction, I was able to attract everyone and everything I needed into my life to finish this book. And as often happens, we were connected with just the right people. I researched options for publishing, and told a friend and colleague about the book. She just happened to have a client who was a book editor! So, when Lisa connected us with Heather (editor) and April (publisher), we knew God had guided us to the team who could help us tell our story. I am so grateful – I knew it was meant to be because everything was falling into place.

It was not always easy. At one point during the process of writing this book, I told Paige, "I can't do this!" She immediately said, "Yes you can!" She motivated me to continue with the book. She created a Google document

so we could work on it together and continue to address all the technical issues. Without her, I do not know if I would have had the courage to move forward. Paige has been such an inspiration to me.

BECOMING FEARLESS

There is one thing I know for sure: anyone can do, have, or be whatever they truly desire – but first, you must have faith. I begin each day reading from my daily affirmation book and making a list of everything for which I am grateful in my gratitude journal. I surround myself with healthy, positive individuals. I enjoy reading literature that will help me grow and become a better person.

My goal is to inspire others to be the best version of themselves – living a healthy, happy, fulfilled life. I want to be a voice for people who live with an invisible injury. I will continue to do research on TBIs, so that I can assist others who have suffered trauma or are coping with a brain injury.

I believe the Lord saved Paige on the night of the accident – she could have died. I am forever grateful that she is still on this earth. I will continue to search for holistic remedies to aid in her recovery, which will be a lifelong challenge.

Three years after the accident, I now live a life of happiness, opportunity and freedom. We become what we think about – I am living proof. It took me many years to finally love and accept myself for who I truly am. I am grateful for all of the experiences in my life, because they made me who I am today.

It is never too late to start over to create the life of your dreams. It just takes one step at a time. What you see today did not happen for us overnight. This is three-plus years in the making, and we have much farther to go. We want to continue feeling happier and healthier, and we want the same for everyone else.

The most significant lesson I have learned from our journey: never take today for granted – no one is guaranteed tomorrow. Become fearless, and you can live a life you love.

Roberta and Paige in February 2022, before
Paige performed at the Booked Naples event.

Paige and her brother Jake relax after the
Booked Naples event in early 2022.

AFTERWORD

MYSTERY SOLVED

An unexpected blessing resulting from Paige's accident was that I solved a lifelong mystery. I have come to believe that when I was a young girl, I also sustained a TBI. When I was young, I spent a lot of time at my grandparents' house, which I really enjoyed. One day when I was 4 years old, while at their house, I accidentally fell a few feet onto a concrete pad. I hit my head and was rushed to the hospital where I received stitches. My arm was broken as well.

I cracked my skull, which today would be classified as a TBI. I have suffered from many issues that TBI patients have endured. I am one of the hundreds of thousands of people who have suffered from an undiagnosed TBI.

After years of dealing with issues resulting from my fall, I have finally learned how to cope with most of them. I focus on what I can do, not on what I cannot do. Now that I know what the symptoms of a TBI are, it all makes sense. I had always wondered why no medication ever seemed to help. Instead of treating the symptoms, there should have been a better diagnosis of the underlying cause of my issues.

My injury occurred around 1972 at a time when there was not sufficient research supporting TBIs – and after time, I **looked fine.** However, there has been a lot of research done in the past few years on concussions and brain injuries. Research shows that approximately 1.5 million people sustain a TBI every year – many are never fully diagnosed.

If you are still seeking answers, we hope this book has encouraged you to try some of the solutions we have found. We also urge you to do your own research on new and developing therapies. And – never, ever give up.

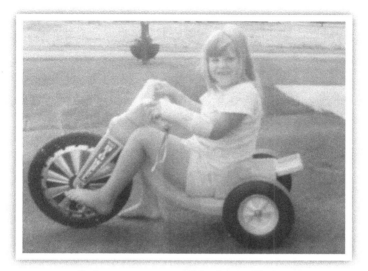

Roberta at 4 years old, after suffering
a traumatic brain injury.

APPENDIX

CONTINUED THERAPIES

Although we wish we had known more about TBI at the beginning, we have learned a lot in three years. Here is what we know now (although we are still learning):

EATING FOR YOUR BRAIN

- Fuel your body with good nutrition.

- Eat a plant-based, whole-food diet.

- Limit processed food, dairy, gluten, sugar and alcohol.

- Eat foods that contain antioxidants that help fight free radicals (molecules that cause inflammatory conditions, hypertension, neurodegenerative diseases, and cancer).

- Some of the best brain foods are: flaxseed, dark leafy greens, blueberries, avocados, walnuts, legumes, chia seeds, pumpkin seeds, squash seeds, eggs, wild-caught fatty fish, turmeric root, and dark chocolate.

HYDRATION

- Water is essential for hydration.

- Avoid soda and energy drinks completely, as they have zero nutritional value and are harmful to your body.

- If you do drink coffee, it is essential to drink organic coffee. Studies have shown there are pesticides in regular coffee.

- Lion's mane mushroom coffee is a nice option and has been found to stimulate the growth and repair of nerve cells. It also supports memory and concentration.

EXERCISE

- Meditation and yoga are beneficial to health and overall well-being, and help with depression and anxiety. They also strengthen the immune system, reduce blood pressure, and lower cholesterol levels.

- Walking and moving the body helps to calm the mind.

HOLISTIC REMEDIES

- **Red light therapy** (photobiomodulation), which uses light-emitting diodes (LEDs) to deliver light in the visible red (RLT) and near-infrared (NIR) wavelengths, stimulates the body's natural healing and regeneration process. Studies have confirmed many positive effects on the brain, such as increased energy production (ATP), increased neuroprotection, and reduced inflammation. There are a variety of options, and I encourage you to do additional research.

- **Craniosacral therapy** (CST) is a gentle hands-on technique that uses a light touch to examine membranes and movement of the fluids in and around the central nervous system. This technique, combined with dry needling, was effective in Paige's recovery.

- **Hyperbaric oxygen therapy** (HBOT), which involves breathing pure oxygen in a pressurized environment, helps the blood to promote healing and repair damaged cells. Although the research is controversial, HBOT has been shown to help in the recovery of a brain injury. (Although Paige did not receive HBOT, she has had other multiple oxygen therapies.)

- **Vestibular rehabilitation therapy** (VRT) is a specialized form of physical therapy used to treat and

improve symptoms caused by vestibular disorders, including imbalance, vertigo, and dizziness.

SUPPORT GROUPS

- There are many support groups out there for TBI survivors and caretakers – in person and online. Every injury is different, but many survivors experience similar issues. These groups are especially helpful for caregivers to understand what is going on with the patient and why they behave as they do.

TIMELINES OF EVENTS

2018

September 9: Paige's accident

September 10: Roberta receives a call about the accident

September 14: Paige is released from the first hospital

September 16: Paige goes by ambulance to the emergency room

September 21: Paige is released from the second hospital

October 2: Paige begins physical therapy

2019

July 15: Paige begins treatment with Ohio State University Wexner Center

August 26: Paige continues her education at the University of Cincinnati

September 16: Paige auditions for *The Voice*

October 24: Paige creates social media accounts called Paige's Vocals

2020

February 15: Paige starts performing live at open-mic nights

May 4: Paige graduates from the University of Cincinnati

June 12: Paige starts her first job after the accident

2021

February 26 and March 24: Paige has MRIs completed; discovers remaining damage on all four injured areas of her body

July 31: Paige performs in her first show with original music

ACKNOWLEDGMENTS

I am so grateful for everyone in my life; and to you, the reader – I want to thank you from the bottom of my heart.

I am the strong woman I am today because of my parents, Bob and Margie, who raised my sisters, Debbie and Diane, and me with good values in a comfortable home. Dad, your work ethic gave me the drive to become an entrepreneur. Mom, your strength taught me to keep going, even during the toughest days. I am forever grateful for all of you.

I have been blessed with two amazing children who are the light of my life! Thank you, Paige, for teaching me courage, patience, and the will to move forward. With your incredible strength and determination, you continue to heal and encourage others at the same time. Thank you, Jake, for always being there for me and for making me smile – even in the toughest times. You have been my rock through everything.

We are so grateful for our family and friends, who supported us through this journey; they were patient while we disappeared for a time to focus on writing this book.

Thank you, Lisa Witsken, for your friendship, and for introducing me to your client, Heather Desrocher, who became my editor. Heather, I am so grateful for your guidance, expertise, and intuitive thoughts that helped piece everything together. Thank you to April O'Leary, and everyone at O'Leary Publishing who helped during the writing and publishing process, for listening to our vision and guiding us during the creation of this manuscript.

A special thanks to Noir Media for your creativity in capturing our vision for the front and back covers, allowing our book to come to life!

To anyone healing from an invisible injury, we understand your struggle. Many people are suffering in silence from past trauma, or from an injury no one can see. You are strong, and can make it through anything with faith, gratitude, and a determination to heal.

If it were not for my mentor, Bob Proctor, this book would not have been possible. Your program came into my life at the perfect time, and I am forever grateful. Because of your teachings on manifestation and meditation, I followed my intuition to write this book. You are dearly missed.

Finally, without my faith in God, I do not know how I would have made it through the past few years. My faith in God is the reason I am here today.

ABOUT THE AUTHORS

ROBERTA CAMPBELL KNECHTLY

Roberta is an educator, author and entrepreneur. She studies personal development and is passionate about health and wellness. This passion, along with her Christian faith, helped her when she became the full-time caregiver for her daughter Paige, following an accident that left Paige with a traumatic brain injury. Roberta is a devoted mother of two and committed to educating others about the invisible nature of a TBI and continues to research alternative treatments for healing. For more information about Roberta and to order *She Looks Fine*, visit

www.shelooksfinebook.com

https://linktr.ee/shelooksfineofficial

PAIGE KNECHTLY

Paige is a health advocate, recording artist and author. She has a degree in health promotion and education from the University of Cincinnati (UC) and carries a great passion for serving others. During her final year at UC, Paige was

hit by a car as a pedestrian, and suffered a traumatic brain injury. While maintaining her strong faith and using the experience and knowledge she has learned in her recovery so far, she teaches others self-healing techniques and promotes patient advocacy.

For Paige's music, social media, and more, visit https://linktr.ee/paigesvocals.

CPSIA information can be obtained
at www.ICGtesting.com
Printed in the USA
JSHW010148290822
29811JS00006B/14

9 781952 491405